DÉCOUPAGE

DÉCOUPAGE

Paper Cutouts for Decoration
and Pleasure

DEE DAVIS

With 131 illustrations, 54 in colour

THAMES AND HUDSON

Dedicated to my precious granddaughter, Amy Gilkes.
Special thanks to Peter Davis, Laurie Gilkes-Weston,
Margaret Gilman de Luca, Patricia Nimocks, and
Robert Wallach for their support and encouragement.

Line drawings by John Kaine

British Library Cataloguing-in-Publication Data

A catalogue record for this book is available from the British Library

ISBN 0-500-01628-3
Printed and bound in Singapore

CONTENTS

INTRODUCTION

Twenty-five years ago I was first introduced to découpage, when a variety of gorgeous lamps in an antique shop in Middleburg, Virginia, just intrigued me. I couldn't wait to find out how to do it and clearly had to try it for myself. The idea of cutting, assembling, and gluing paper to decorate a surface according to my own design fascinated me. A recent auto accident had curtailed my painting, so I put aside the large canvases and lost, or rather found, myself happily creating "painting with scissors." Like many others, I have collected ephemera for years. It was wonderful fun cutting and composing these pictures; working on a three-dimensional object instead of a flat canvas was a fascinating challenge.

Over the years, and from a great many sources, I've researched the history of découpage (derived from the French *découper*, to cut out). To me, the history is an integral part of the craft and I do hope you find it interesting.

The art of self-expression can take many forms, but few are as easy to learn and quick to complete as découpage. There is great pleasure in creating something useful and beautiful, and both pride and satisfaction in the accomplishment. You are doubly rewarded by the appreciation and recognition of others; your self-esteem climbs a few notches that fine day when you're first asked to sell your work.

I hope this book will inspire and encourage you as well as instruct. "And gladly wolde he lerne, and gladly teche," wrote Chaucer in *The Canterbury Tales*—and gladly I share my knowledge with you and hope that you, too, will share yours with others.

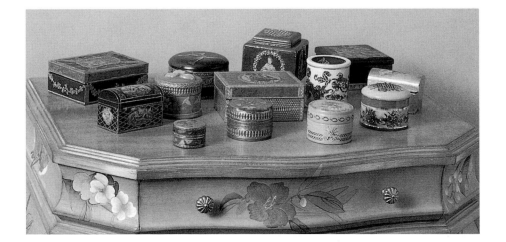

HISTORY

THE ART OF PAPER-CUTTING

Paper-cutting has been a tradition for many centuries, with wide-ranging styles, techniques, subject matter, and skill. Artists from each country developed a recognizable style and content, a reflection of their own culture and customs.

Since papermaking originated in China some two thousand years ago, it follows that paper-cutting began there too. Early uses of paper were associated with religious ceremonies and paper itself was considered a sacred material. Cutouts, rife with symbolism, were traditionally burned at funerals to accompany the departed soul to the next world. Cutouts decorated altars inside homes, while outside "Door Gods" assured the family's safety from harm. Red paper cutouts denoted "congratulations" and were a sign of celebration within. The Chinese used both knives and scissors to cut intricate and delicate flowers, birds, and animals, many with very fancy surrounding frames.

Japanese *mon-kiri* was the popular art of cutting paper crests. Samurai warriors took great pride in the decorations on their weapons and banners; and their families still use the crests as emblems. They introduced a technique to achieve more intricate paper cutouts by folding paper many times before cutting.

Left: *Chinese paper-cutting tools: scissors, knife (right), and two punches.*

Opposite: *Jewish and Christian paper-cutting. Left: Mizrah (decorative east wall hanging) by Israel Dov Rosenbaum, Podkamien, Poland, 1877. Right: The Lord's Prayer, inscribed on the back "Cut by T. Hunter 1786."*

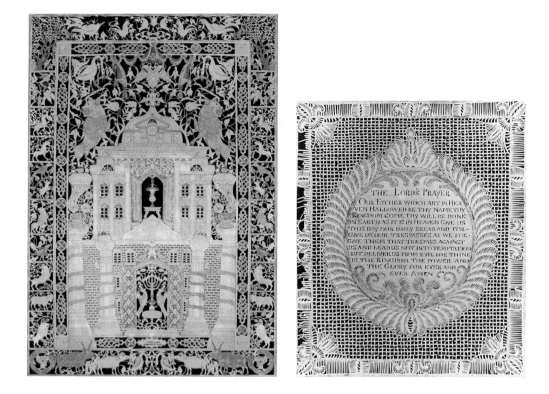

In Turkey, découpage called *kat'i* developed into a fine art, and became so popular that a Kat'i Guild was established. Its members specialized in calligraphic cutouts which they created with assorted knives of best tempered steel. Découpage was used in a 16th-century Iranian manuscript by the poet Sadi, whose poems were surrounded by a stunning border design of animals, birds, and foliage. Poems, documents, manuscripts, and calligraphy were also framed with découpage borders of similar motifs.

After paper was introduced to Europe in the 12th and 13th centuries, each country produced its own ethnic paper decorations. Since a piece of paper was quite affordable, scissor-snipping began as a popular pastime and became a highly paid profession. Fancy cutwork borders were used for legal documents, wills, and marriage contracts, as well as for Christian and Jewish religious texts. The main cutting tool was a knife with a small steel or silver blade, called a *canivet*. Some ladies used their little embroidery scissors.

Polish *wycinaki* were cut with the large, unwieldy shears that shepherds used for sheep-shearing. Family members cut intricate geometric, stylized designs, which they pasted on cradles, chests, boxes, and ceiling beams.

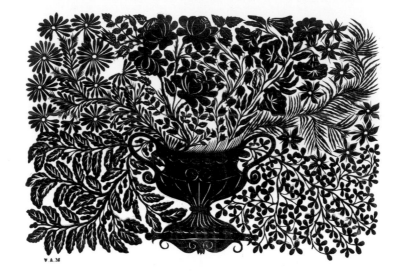

Intricate English cutting of "Flowers in a Vase"
by Ann Thorneley (1794–1863).

In Switzerland and Germany, every schoolgirl was expected to be proficient in the craft of *Scherenschnitte*, in which they snipped their own designs of birds, animals, children, and trees with small sewing scissors. When the German colonists settled in Pennsylvania in the 17th century, they introduced scissor-snipping to America. There it was used initially for detailed borders on birth certificates and marriage licences. In Victorian times, paper-cutting was most popularly used for home decoration.

For centuries the indigenous peoples of Mexico and Central America used cut-paper images in their ancient religious ceremonies. The Aztecs cut bark-paper figures, 3–10 in. (8–25 cm.) high, representing the spirits of water and crops. These figures, dedicated to the gods, were placed on the altar during their elaborate rituals.

The Industrial Revolution, toward the end of the 18th century, made paper and scissors much more available. A growing group of professional artists cut "portraits in shadow" (profiles of figures). These very popular "silhouettes" were named after Etienne de Silhouette, Louis XV's Minister of Finance. The wealthy and famous sat for their portraits, cut from black paper and mounted on white backgrounds. There are numerous "shades" of George and Martha Washington. The most prolific and famous artist of the time was Augustin Edouart, who cut almost ten thousand portraits; during the ten years he spent in America he made portraits of four presidents.

Silhouettes by Augustin Edouart (1798–1861): John Connell (23 September 1836), his brother David Connell with Mrs. Connell, Sr., and Arthur Connell (10 April 1832).

Mementos called "mourning pictures," with religious motifs, were displayed in 19th century houses as memorials to the deceased. Small cutouts were framed with poems or embroidery, sometimes a lock of hair, and placed on the parlor table to keep the family's memories alive.

On a happier note, the paper valentine, frothy with cut lacework of cupids, hearts, and flowers, was made by hand for sweethearts and loved ones. The invention of the embossing machine replaced handwork with the mass production of commercial valentines.

THE DECORATIVE ARTS

The advent of etching and engraving, new methods of duplicating prints, provided the wealth of material that inspired the glorious 17th-century découpage. After the invention of the Gutenberg press (c. 1450), the popularity of prints created a new European industry of print publishing. There were hundreds of master printers in 16th-century Venice; the Remondini of Bassano published a variety of designs on fine paper made specifically for decorating furniture. Famous artists such as Watteau, Boucher, Fragonard, Berain, Piranesi, Engelbrecht, Huet, and especially Pillement were reproduced by the inexpensive graphic art of printing. There was a remarkable selection of styles and subject matter, classical and oriental, pastoral

and worldly; all manner of botanical flora and fauna, both real and imaginary. Flowers and fruit were consistently used, arranged in bouquets or large cornucopias, hung in garlands and strewn in ribbons. Scenes of romance, music, and dance combined architectural gardens inhabited by large and small animals, domestic and fanciful birds, and butterflies in flight. The fantasy world of mythology, allegory, heroics, and grotesque art were combined with heraldic signs and symbols. Jean Pillement's *chinoiserie* fantasies of mandarins, monkeys, parasols, and pagodas must have inspired the Brighton Pavilion and many follies. Printmakers in Nuremberg and Augsburg made many series of prints for the popular German découpage.

The East India Company's opening of trade routes with China, Korea, Siam, and Japan developed a flourishing import business. Early 17th-century Europe was captivated and demand for the magnificent lacquered *objets de Chine* far exceeded supply. The rage for Eastern lacquer spread quickly through the royal courts of Europe, to the urban middle class, then to the provinces. To fill the demand and fatten their own purses, the European Guilds began imitating oriental lacquer furniture and decorative objects. The "westernization" of oriental styles and motifs often resulted in somewhat bizarre misconceptions. *Chinois fantastique* was proudly collected and displayed by the enlightened society in every palace, wealthy town house, and stately home throughout the length and breadth of Europe.

A Treatise of Japanning and Varnishing by John Stalker and George Parker was published in Oxford in 1688. This classic became the practical guide for imitating the oriental lacquer, and described how to make, use, and polish shellac to a high luster. It also included engravings of suitable designs for furniture. Lacquer originated in China from the gummy lac or juice of a small tree, *Rhus vernicifera* (poison sumac), not grown in Europe. Later the Japanese produced a finer lacquer of superior luster and patina. A mixture of shellac and alcohol, *sandracca* (made from the sandarac tree) became the European substitute for lacquer, which was unavailable. This protected the decorated furniture, screens, trays, tables, and boxes. The name "lacquerware" was a synonym for both shellac and varnish finishes. The term "japanning" originally referred to the imitation of oriental lacquer; later the term was applied generally to the art of decorating surfaces. Even today, polyurethane and acrylics may be referred to as "lacquer."

The European imitation of lacquerwork in the 17th and 18th centuries became a major industry in Italy. There were more artisans employed in the three hundred

or more Guild-dominated Venetian workshops producing wood furniture than in any other craft. Venice, "Queen of the Adriatic," was internationally known for its painted and lacquered furniture called *lacche veneziane*. Every piece was in great demand and highly valued. The Venetian style was distinctive for its opulent use of all the elements of decoration and its outstanding ways with striking colors. The ateliers flourished with orders for carved wood pieces (made from inexpensive wood) either painted or gilded, but above all lacquered.

To cope with the tremendous demand, apprentices to the master painters experimented with cutting out engravings, designing and gluing the cutouts to the furniture, then coating with *lacca. Ecco!* a quicker and cheaper substitute for the handpainted decorations of the expensive *dipintori*. This new method naturally incurred the master painters' wrath because it eliminated their services, so they scornfully called it *arte povera* (poor man's art). Historically, *lacca contraffatta* (imitation lacquer) is the Italian term for découpage, although the most commonly accepted name is the French one.

Once perfected, *arte povera* increased in value and importance to Italian collectors and foreign travelers. The shops in the Piazza San Marco in Venice filled with this new *industria povera* and prices increased with the demand. The Venetians often combined French, German, and Italian engravings, either in black-and-white or handpainted. They lightly polychromed the engravings, allowing the lines to show through; then the watercolors were made colorfast with a gum arabic solution. They applied successive coats of *lacca* which "ambered" and darkened over the years.

These polychrome engravings were used to decorate a variety of household objects, mirror frames, trays, candlesticks, vases, jewel cases,

Sumptuous Italian bureau-cabinet (trumeau), 9 ft. 1 in. (2.77 m.) high, with superb lacca contraffatta *decoration, made c. 1740.*

toilette sets, fans, writing desks, and an infinite variety of boxes. Pale yellow, blue, green, pink, and ivory were popular background colors for the delicate, harmonious palette. Occasionally, small panels or interiors were painted in dark contrasting colors like regal blue, rich olive green, deep coral, and sealing-wax red. These Rococo panels were framed in a variety of ways, sometimes with gilding, striping, friezes, or cartouches. Not only did the Venetians excel in *chinoiserie* themes, some artisans handpainted backgrounds of landscapes, clouds, and foliage for the small Arcadian figures découpaged in the foreground. The advent of color reproductions provided an even greater wealth of subject matter.

The introduction of the secretaire, or *scriban*, around 1730 was of great importance. The *scriban*, with its interior arrangement of small drawers, pigeon-holes, and secret compartments, provided safekeeping for valuable documents. There isn't any satisfactory explanation for the 18th-century French misconstruing the name *l'art scriban* for *arte povera*. Perhaps an Italian princess, arriving at the French court with her dowry documents hidden in her découpaged *scriban*, prompted the misnomer and it has since persisted. Serge Roche, an authority on Venetian lacquer, explained in an article on "Le Décor Scriban" in *Plaisir de France*: "From the 17th century one sees simultaneously in many European countries a type of furniture made in three parts, combining tomb-shaped [*tombeau*] chest, a desk, and a cabinet. . . . One could find many examples in England, Germany, Austria, and Italy (particularly Genoa and Venice) and as far as the U.S., where it was called 'desk and bookcase'." The Dictionary of the French Academy gives an explanation: a traveler, admiring the marvelous "*scribanne*," heard what was said and confused the furniture on which one writes with its decoration. As a consequence, the word came to designate in France all the objects of the *lacca povera*.

In France, these Italian imports quickly became the vogue and the ladies of Louis XVI's court all commissioned work done in the manner of the *scriban*. They themselves spent many hours avidly cutting out original engravings done by the great French artists of that time. Engravings of Boucher, Fragonard, Watteau, and Pillement which were used for their *art scriban* are still universally popular. The Cooper-Hewitt Museum in New York has an elegant lacy découpage cutting attributed to Marie Antoinette. Pillement's fantasy world of *chinoiserie*, capricious and exotic, saturated the market for multiple "visions of Cathay."

The Neoclassical replaced the Rococo style of the early 18th century during this period of intense creativity. A new art of allegory flourished, depicting both pastoral

Paper-cutting attributed to Marie Antoinette, c. 1775. Découpure
(cutting and pasting) was the fashion in French society and at court.

and worldly scenes. These designs turned to nature; themes of love portrayed Diana, Venus, cupids, and cherubs in a pastoral Arcadia. The French created a new style of asymmetrical ornamentation with curves twisting into scrolls and arabesques. The four Martin brothers, skilled cabinetmakers, developed and manufactured their own special varnish called *vernis Martin*, which was almost as fine as the Japanese lacquer. Their fame throughout Europe kept their factories busy with orders from royal sponsors and nobility. Competitors scrambled to imitate their skills.

The large European private collections of *lacca contraffatta* are now scattered among various family members; the largest collection, at the Palazzo Donà Dalle Rose in Venice, is no longer intact. In 1938, the last great exhibition of the most valued and original Venetian lacquerwork was held at the Ca' Rezzonico in Venice. Quoting from the exhibit's catalog, "One is surprised and astonished at the fertility of invention, the fantasy, taste, and grace . . . with which the Venetian artists adapted their talent to so many different objects, to the most varied and curious household furnishings that reflect the whole way of life of the times . . . all these things prove the great talent, the extraordinary taste and originality, and the rich fantasy with which the Venetian artists knew how to work and create. . . .

Outstanding is a *bureau-trumeau* [chest with mirrored cupboard top] of beautiful and richly varied colors." Perhaps the trumeau shown on page 36 is the very one mentioned. These photographs of *arte povera* (pages 35–37) magnificently illustrate and reflect the comments in that catalog.

At Spa, in Belgium, there was a flourishing lacquer industry in "*les boîtes et coffrets*" (boxes and caskets). 17th- and 18th-century Spa was a mecca for European hypochondriacs who shopped for souvenirs to bring home, and so these polychrome *chinoiserie* boxes, known as *bois de Spa*, were dispersed throughout Europe. This cosmopolitan resort attracted many literary celebrities and politicians who purchased elegant writing desks. Following its origin in the 17th century, snuff-box collecting became an obsession for those who had the means. The boxes were made of wood, brass, and precious gold in assorted shapes. Francis Garden (Lord Gardenstone) brought one of the best lacquerworkers from Spa to Scotland and there he established a thriving business manufacturing snuff-boxes. The "*Siècle de la Tabatière*" (Age of the Snuff-Box) found many uses for these items. When not carried in a pocket, they were displayed in showcases or on tables and mantelpieces at home.

In 18th-century England the popularity of découpage grew steadily, becoming a favorite pastime. Aristocratic guests at the great country houses spent many leisure hours displaying their skills at "japanning." This art of decoration was so named because of its similarity to the Japanese lacquerware and the influence of the book, *The Ladies Amusement; or, Whole Art of Japanning Made Easy*, by Robert Sayer. First published c. 1760, this large volume reproduced some 1,500 designs with detailed instructions and "receipts" for coloring, cutting, composing and varnishing. "The Art of Japanning, and Decorating with various Designs, has prevailed so much of late from the superb Cabinet, to the smallest Article of the Toilet . . . ," Mr. Sayer wrote. "The Variety of Objects admitting almost infinite Combinations and being likewise singly agreeable. . . . With *Indian* and *Chinese* Subjects greater Liberties may be taken. . . . The Grotesque is a Taste which at present

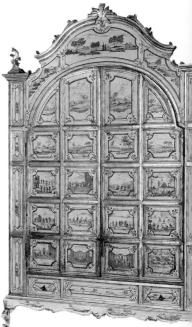

Mid-18th-century japanned highboy chest. A large surface elegantly composed of a variety of small shapes.

```
                              T H E
   L A D I E S   A M U S E M E N T;
                     O R,   W H O L E
   A R T  of  J A P A N N I N G
           M A D E   E A S Y.
   Illuſtrated  in  upwards  of  Fifteen-Hundred  different  DESIGNS,  on  Two  Hundred  Copper  Plates;
                       C O N S I S T I N G.
   Of  Flowers,  Shells,  Figures,  Birds,  Inſects,  Landſcapes,  Shipping,  Beaſts,
                   Vaſes,  Borders,  &c.
   All  adapted  in  the  beſt  Manner  for  joining  in  Groupes,  or  being  placed  in  ſingle  Objects.
                       D R A W N  B Y
       P I L L E M E N T  and  other  Maſters,
           And  excellently  E N G R A V E D.
               To  which  is  added,  in  LETTER-PRESS,
   The  moſt  approved  Methods  of  JAPANNING ;  from  the  Preparation  of  the  Subject  to  be  decorated,  to  its  being  finiſhed :
                       W I T H
       D I R E C T I O N S  for  the  due  Choice  of  COMPOSITION,  COLOURS,  &c.  &c.
               The  S E C O N D  E D I T I O N,
   N. B.  The  above  Work  will  be  found  extremely  uſeful  to  the  PORCELAINE,  and  other  Manufactures  depending  on  Deſign.
                   L O N D O N:
   Printed  for  ROBERT  SAYER,  Map  and  Printſeller.  at  the  Golden-Buck,  oppoſite  Fetter-Lane,  Fleet-Street.
```

Title-page of The Ladies Amusement *by Robert Sayer, c. 1760.*

much prevails. . . ." He continues, "The Figures are to be first painted in proper Colours . . . [then] the several Objects you intend for Use must be neatly cut round with Scisars, or the small Point of a Knife; . . . brush'd over on the Back with strong Gum-water . . . and with a Pair of small Pliers, fix them on the Place intended. . . ." He recommended: "Varnish again . . . at least seven Times, tho' if you varnish it Twelve it will be still better." Lastly, follow by polishing twice with "a flat Piece of Cork and Tripoli mix'd with Water"; then let it stand three days, followed by a final hand polishing with rottenstone to achieve a fine mellow patina.

More than a century earlier, as Hugh Honour wrote in *Chinoiserie* (1961), "so great, indeed, was this vogue for exoticism in Jacobean England" that not only the landed gentry, but even small households occupied the evenings with handicrafts. Inexpensive papier-mâché was a popular background for decorating, even for a table or chair.

The development of lithographic printing in the 1800s produced chromolithographs (later called "scrap.") The pictures had remarkable color, tone, and texture. Massive quantities of German scrap, die-cut and embossed, were exported to England for decorating trunks, boxes, Biedermeier furniture, and leather and wood screens. Lord Byron chose boxers and prizefighting scenes for one side of his four-panel screen; theater scenes with numerous portraits of actors and actresses are

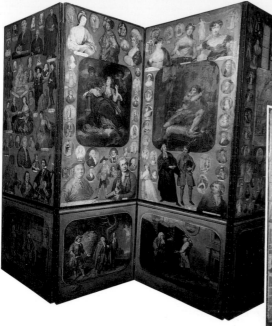

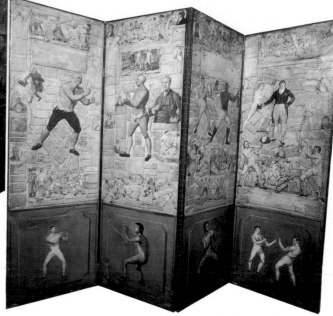

Screen made by Lord Byron c. 1811–14 with theatrical subjects on one side and boxing subjects on the other.

represented on the reverse. Mass-produced scrap was a huge commercial success. Queen Victoria had a scrapbook collection, and so did almost everyone else. Victorian ephemera collections were all the rage both for decorating and for scrapbooks. Victorian découpage became the vogue, with popular designs of hearts and flowers, children, animals, cherubs—all sentimentally and romantically stylized.

In *Collecting Georgian and Victorian Crafts*, June Field states: "The Victorians had crazes for things—manias, you might say. One of them, back in the 1840s, was for decalcomanie, literally derived from the French *décalquage* or *décalque* [a transfer or decal] and of course, *manie*, a mania or craze." A kit for this process was advertised for £2 in *The Lady's Book of the Month* in 1867.

"Penwork [was] a type of decoration applied to japanned furniture in the late 18th and early 19th centuries, mainly in England," according to *The Penguin Dictionary of Decorative Arts* by John Fleming and Hugh Honour. "Furniture to be treated in this way was first japanned black, then the patterns were painted on in white Japan and finally the details and shading were executed in black Indian ink with a fine quill pen. The effect is delicate and lacy, rather like etching in reverse." The surface and varnish (shellac) have aged some of the white to a dark golden orange. It very much resembles the engraved ivories of southern India.

A collection of exclusive English penwork, combined with both découpage and gilding, was displayed in a major exhibit at the Hyde Park Antiques Gallery in New York in 1989. There were rare examples of antique boxes, Regency tables, and unusual ladies' fans, all quite spectacular and very elegant.

In both England and Ireland there arose one of the most charming and innovative trends in interior decoration. Picture galleries, called "print rooms," were embellished with engravings, some original and others reproductions. The subject and style were chosen according to the tastes and interests of the owner of the house. Compositions ranged from simple elegance to crowded abundance. Architectural compositions of black-and-white engravings were glued on the wall, "framed" with assorted paper borders and "hung" with paper ribbons, bows, rings, and classical ornaments. Groupings were linked with garlands and swags of flowers and fruits, cording and tassels, also of paper. Symmetrical groups of engravings were carefully balanced according to the architectural details in the room. The most imaginative rooms were done with the greatest selection of print sizes and shapes. Rectangles, squares, octagons, circles, and ovals were hung in vertical and horizontal arrangements on walls of buff or pale pastels.

In England, as a historical note from the National Trust explains, "Throughout the second half of the eighteenth, and well into the last century, when engraving was the only method of reproducing paintings, whether of 'the Masters' or of 'views', 'ruins' and so on, and when no library or collection was complete without its portfolios and albums of prints, it was possible to buy sheets of borders, bows and other ornaments. . . . The borders were cut out and used as frames for arrangements of prints pasted to the walls." In Ireland, both Dublin and Cork had printsellers, engravers, and copperplate printers who sold "Borders and Festoons for Rooms and Pictures."

Print rooms were designed by professionals and by the house owners, who often traveled abroad searching for prints. The choice of theme to accord with the owner's enthusiasms narrowed the field considerably. Quoting The Hon. Desmond Guinness of the Irish Georgian Society, "Thomas Chippendale's firm supplied a bill for one. . . . The earliest reference to a print room was formerly accepted to be a remark in a letter from Horace Walpole to Sir Horace Mann, dated June 12th, 1753: 'The room on the ground floor nearest to you is a bedchamber, hung with yellow paper and prints, framed in a new manner invented by Lord Cardigan, that is, with black and white borders printed.'" In 1769 Arthur Young wrote, "We

entered a breakfast-room, elegant indeed. Prints pasted on a buff paper with engraved borders; and all disposed in a manner which displays great taste. The prints are of the very best masters, and the ornaments elegant."

A number of print rooms have survived, sometimes having been carefully restored; for example, in Queen Charlotte's Cottage in Kew Gardens, and at The Vyne, near Basingstoke, Hampshire. Bretton Hall in West Yorkshire boasts a bedroom covered in Piranesi prints of Roman buildings and scenery. At Blickling Hall, near Aylsham, Norfolk, the inventory of 1793 listed "The Copper Plate Room" in reference to engravings made from copper plates.

The print room at Ston Easton Park, Somerset, was restored in the 1960s. The classical elegance of the print arrangement around the cupboards features delicate garlands, swags, small urns, and cameos interspersed with an occasional grouping of miniatures on a pale-blue background.

The apogee of architecture and art is found at Woodhall Park, Hertfordshire. This fabulous period print room is signed across the mantelpiece, "Designed and Finished by R. Parker 1782." The catalog lists more than three hundred engravings (mostly Italian) cut into ingenious and curious shapes, lavishly adorned with details that emphasize the architectural arches and coved ceiling.

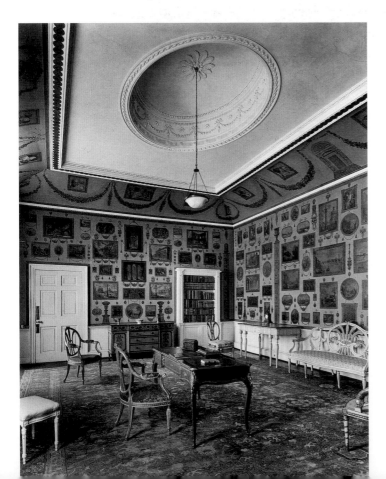

Left: *Print room at Woodhall Park, Hertfordshire, by R. Parker, 1782.*

Opposite: *Lady Louisa Conolly's print room at Castletown, County Kildare, c. 1770.*

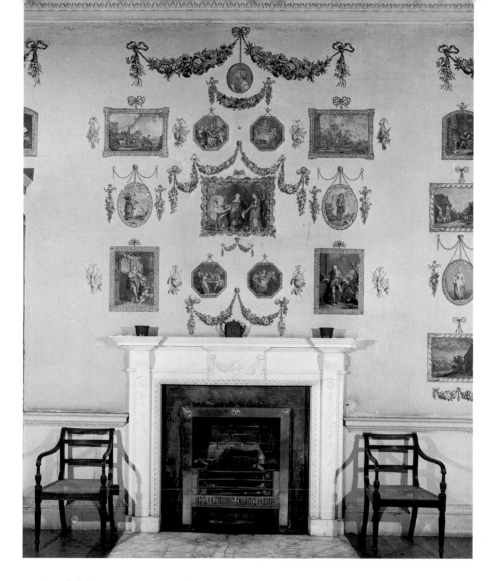

Stratfield Saye, in Hampshire, was a gift to the Duke of Wellington after his victory at Waterloo in 1815. Some of the original nine print rooms remain, for which the duke himself chose military, sporting, and landscape subjects centered on a large circular Wellington shield (see page 39). Another print shows Napoleon in exile gazing over the sea. The first floor has a small print room, and a long print gallery; upstairs, several bedrooms are done in a plainer style.

The most magnificent Irish print room is at Castletown, County Kildare, in the first great Palladian house built in 18th-century Ireland. The mistress of this splendid country house, Lady Louisa Conolly, personally spent years collecting prints and borders. A sketch for their disposition is on display in that room. The gradations of gray and black on the cream walls show to advantage the magnificent compositions on each wall, all in perfect harmony. Spaced in appropriate groupings, the prints are unified and linked by the curves of swags, garlands, and ribbons.

Figures are the main subject, with framed ovals, circles, and octagons alternating with each rectangular shape and all attached with a variety of ornaments.

Mrs. Mary Delany wrote in 1750, "It rained furiously, so we fell to work making frames for prints," and in a later letter to her brother, "I have received the six dozen borders all safely. . . . They are for framing prints. . . . I must have prints."

Mary Delany (1700–1788) was a creative artist skilled at sketching and embroidery, inspired by her love of flowers and nature. Her crowning achievement was her highly original creation of "paper mosaicks," perfect portraits of botanical specimens (see page 38). At age 72 she started paper-cutting and produced 972 "*Flora Delanica*" before her eyesight failed at 82. Admired and collected by King George III and Queen Charlotte, these unique collages have been preserved and can be seen at the British Museum in London. Ruth Hayden wrote in *Mrs Delany: Her Life and Her Flowers*, "Collages [are] built up of often very small, separately cut pieces of coloured paper representing not only conspicuous details but also contrasting colours or shades of the same colour so that every effect of light is caught. . . . Her quick eye for botanical detail, her highly developed colour sense and her gift of being able to cut out images as easily as she could draw them . . . developed into an art entirely her own."

Mrs. Delany's close friendship with King George III and Queen Charlotte developed from their admiration for her artistry and their shared interest in botany. Her new art of botanical illustration recorded rare plants from the Royal Botanic Gardens. The King sent her horticultural specimens brought to England by explorers, instructing her to "'paint' [them] in paper." The Queen gave her "a beautiful pocket case . . . [which was] lined with pink satin and contained a knife, a sizsars, pencle, rule, compass, bodkin." We can only guess whether she used flour and water or egg-whites to glue the flowers to the matte black paper background she chose consistently. The fineness of her work took many hours and eventually affected her eyesight; she ended her days supported by the King in a small house at Windsor frequently visited by the Royal Family.

Two hundred years later, in 1986, the Mary Delany Flower Collage Exhibition at the Pierpont Morgan Library took New York by storm. A celebrated member of the social and cultural elite in both Ireland and England, she left a permanent legacy of a glorious garden.

Quillwork, a paper substitute for metal filigree, was another popular pastime in the 18th and 19th centuries that flourished in British salons. Devotees rolled

narrow strips of paper into scrolls used for filigree work on frames and boxes and even whole pictures. Often they combined cut-paper work with quillwork for a stunning three-dimensional effect. This can be seen in the Victoria and Albert Museum in London, and also at the Florian Papp Gallery in New York, which held a remarkable exhibition entitled "Rolled, Scrolled, Crimped, and Folded: The Lost Art of Filigree Paperwork" in 1988.

"In the early part of the present century," wrote S.J. Housley in 1896, "the cutting out of figures from paper with scissors still formed one of the common evening diversions of young people." They collected albums of artistic and sentimental cuttings, exchanging them or giving them as presents.

Potichomania was an elegant mid-19th-century fad that remained in style for several decades. Its strange name is derived from the French *potiche*, meaning oriental porcelain pot, jar, or vase, and *manie*, mania or craze. Sometimes it has been called "decalcomania," but I prefer to limit that term to the use of transfers or decals only. Potiche is defined in Thames and Hudson's *Dictionary of Art Terms* as "a covered pottery or porcelain jar without handles. The shape is said to derive from Chinese bronze wine-vessels of the Chou dynasty, 1122–249 BC."

Transparent glass vases or jars were decorated with cutout paper pasted on the interior of the glass; then the background was painted with oil colors. Directions for making a "Vase in Potichimanie" were published in the January 1855 issue of *Godey's Lady's Book* in Philadelphia. The June issue of the same year described an easier method in which cutouts were pasted on the outside of an earthenware vase or jar, then varnished. "Its maker could then fondly imagine the vase as the equal of any Dresden, Sèvres or Chinese porcelain," declared June Field in *Collecting Georgian and Victorian Crafts*. This craze started in France, flourished on the Continent and in England, then "was popular in the United States where sheets of paper printed in colours with motifs appropriate to the different styles could be bought, and indeed featured Dresden medallions, Etruscan designs and Chinese figures and flowers."

An intriguing offshoot of this was the decoration of "witchballs" with Victorian scraps and cutouts. "Witches and witchcraft were regarded as a very real and threatening force in early America. . . . Colonists, wary of the evil eye, hung glass balls called witchballs . . . to

"Vase in Potichimanie" from Godey's Lady's Book, *January 1855.*

safeguard them. Hung outside over doorways, [they] protected all who entered. Within the home, set on mantels . . . or hung from rafters and hooks, they provided additional protection," explained Oliver Butterfield in his article "Bewitching Witchballs" in *Yankee Magazine*. The size of the handblown glass spheres ranged from 2 to 14 in. (5 to 35 cm.) in diameter, with a hole at one end where the blow-pipe was broken off. Now, that hole was too small for even a child's hand to go into, so *how* did they make these magnificent objects? Witchcraft, indeed! One can only surmise that it was similar to building a ship inside a bottle. The slurry white backgrounds are probably plaster, perhaps gesso. Some of the glass has turned iridescent over time, reflecting the light in its prisms—quite appropriate for its magic powers.

The popular arts and crafts of France and England that crossed the Atlantic Ocean were soon imitated by local amateur and professional artisans. An advertiser in the *Boston Newsletter* in 1739 made it known that he would be glad to teach ladies "to japan in the newest method . . . now practiced by most of the Quality gentry in Great Britain with the greatest satisfaction." At that time Boston had only around 12,000 inhabitants, according to Hans Huth in *Lacquer of the West*. Despite the popularity of *lacca povera* techniques in Boston and New York, it seems no known pieces have survived.

Catherine Lynn commented on print rooms in *Wallpaper in America*: "There are scattered bits of evidence that rooms were hung in this way by American decorators." A Philadelphia newspaper advertisement in 1784 offered to create print rooms and to "superintend or do the business of hanging rooms, colouring ditto, plain or any device of prints, pictures and ornaments to suit the taste of his

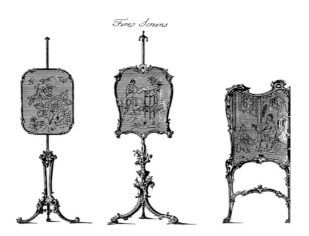

Fire Screens

Fire screens from Thomas Chippendale's The Gentleman and Cabinet-Maker's Director, *1754.*

employers." Utilitarian fireboards—wooden screens placed inside the fireplace in summer—were much in demand. They were usually decorated with vases of flowers surrounded by cut wallpaper borders. There is a charming fireboard at Sturbridge Village, Massachusetts, of a scene of Boston Harbor. Models of freestanding adjustable fire screens are shown in Thomas Chippendale's *The Gentleman and Cabinet-Maker's Director* (1754) with *chinoiserie* motifs for decorations.

Bandboxes, which originated in England, were much in demand in 18th- and 19th-century America. These were tall cylindrical or oval boxes of lightweight wood or pasteboard used for storage and travel. Some were decorated with wallpaper, some were covered with Victorian scrap, and many were handpainted and frequently lined with newspaper. A goodly number of these antiques have survived, and because of today's revival of interest, imitations are now popular.

John Ruskin (1819–1900) provided the ideology for the Arts and Crafts Movement and his influence remains just as profound on the contemporary crafts scene. The crux of Ruskin's theory is that the most beautiful objects are those which most clearly reflect the human effort that went into their making. It was William Morris whose designs led to the revival of the decorative arts in Britain. Morris even mastered the arts of print- and papermaking to produce his own books. He advised, "Have nothing in your house that you do not know to be useful or believe to be beautiful." Many famous Impressionist painters designed their own frames to complement their paintings, giving new importance to the craft of framemaking. James Abbot McNeill Whistler decorated an entire exotic interior to provide a suitable setting for his painting *The Peacock Room* (now in the Freer Gallery of Art, Washington, D.C.).

There are several marvelous books illustrating the glory of Italian *lacca contraffatta*, but which are unfortunately out of print. Try to find them in a museum's library, or a library that specializes in art, so that you can enjoy the photographs and be inspired to create your own masterpieces:

Mobili veneziani laccati, 2 vols., by Giuseppe Morazzoni, L. Alfieri Editore, Milan, 1954–57

Mobili e ambienti italiani dal Gotico al Floreale, 2 vols., ed. Raffaella Del Puglia and Carlo Steiner, Bramante Editrice, Milan, 1963

Mobili italiani del Seicento e del Settecento by Giuseppe Mazzariol, A. Vallardi Editore, Milan, 1963

Lacche veneziane settecentesche, 2 vols., by Saul Levy, Görlich Editore, Milan, 1967.

and practical vehicles for the artist. Certainly they will inspire you, but let me recommend that you start with smaller things first.

For *House Beautiful* I adapted the print room style, adding many découpage details for a rather formal four-panel screen (see page 126). Copies of engravings from *The Ladies Amusement* were used on a second, less formal, screen for a country house. Photocopied reductions proved suitable for a small fireplace screen (below). I can't say how many hours it took to make these—but I can say how pleasurable those hours were.

The découpage tradition has carried on through successive generations, both professionally and as an artistic pastime. Maybelle Manning and her son Hiram learned the art of découpage in 1928 in France. Later in Boston, Massachusetts, they established the Manning Studio, which specialized in the classic style, and used handcolored traditional prints. (See his book, *Manning on Decoupage*.)

"Sister" Parish of the famous decorating firm of Parish Hadley has created many découpage pieces for her own use. Both her daughters make and sell découpage: D.B. Gilbert in Hot Springs, Arkansas, and Apple Bartlett in her Boston, Massachusetts, shop. Her granddaughter, Susan Crater, started selling her glass lamps soon after completing découpage classes with me.

In the 1950s Loretta Howard, a découpeur and collector, spent evenings with her children "in conversation and cutting découpage," according to Linn Howard, her daughter. Loretta découpaged her dining-room table with fruits and flowers intertwined with leaves and stems. She made sets of placemats for her friends. Now Linn is using her mother's antique scrap and prints for her own découpage.

Just a word of warning: this is an addictive craft! Once hooked, you'll be carrying scissors and prints with you everywhere.

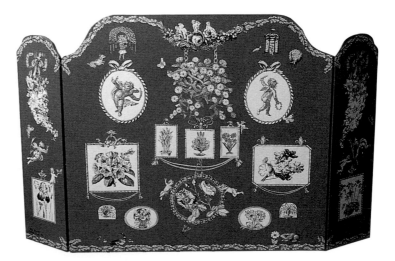

Fireplace screen by Dee Davis in print room style.

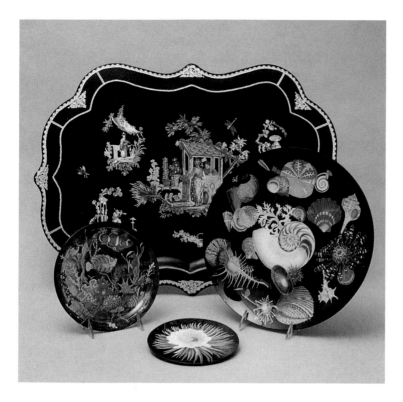

Dark backgrounds are dramatic. Gold trim enhances the Chippendale tray's shape and Pillement chinoiserie by Eirene Herd. Linn Howard découpaged antique handcolored sea motifs on both glass trivet and large plate. Stylized fish swim in a sea of translucent glass stain.

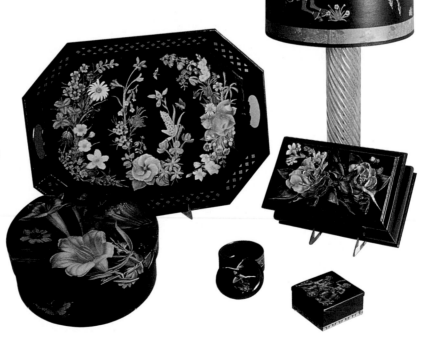

An Indian "wedding horse" prances on the lampshade, banded with its border—quick and easy. Veronica Voelkle sculpted those gorgeous flowers (with epoxy putty) on the rectangular box.

33

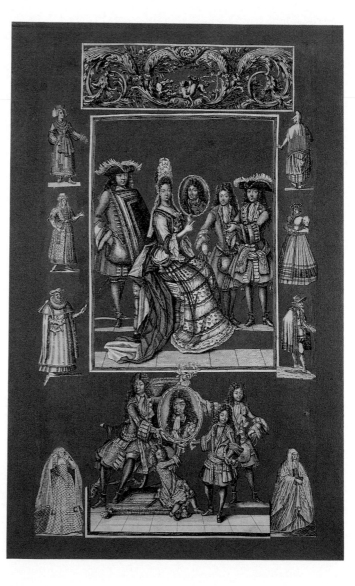

This antique English glass sphere and stand, c. 1875, approximately 12 in. (30.5 cm.) in diameter, is a rare find. Cutouts and chromolithographs were découpaged on both pieces with a chalky white background. But whose hand could fit into the tiny opening at the bottom of that globe? Composition on a double curved tapering shape is quite a challenge; this one was accomplished exceptionally well. The antique witchballs I've seen seemed quite unrelated to scaring anyone, let alone a witch.

"One of a set of framed découpage pictures from the very early 18th century," according to the Stephanie Hoppen Gallery in London. The black-and-white engravings for this "Ancestral Heritage" series make a very impressive framed grouping with a very impressive price. If you yearn to try this, browse through the bins at old print shops for engravings not fine enough to frame. Cut out and compose all the good sections, at a fraction of the cost of prints in mint condition. You might decide to handcolor them as well.

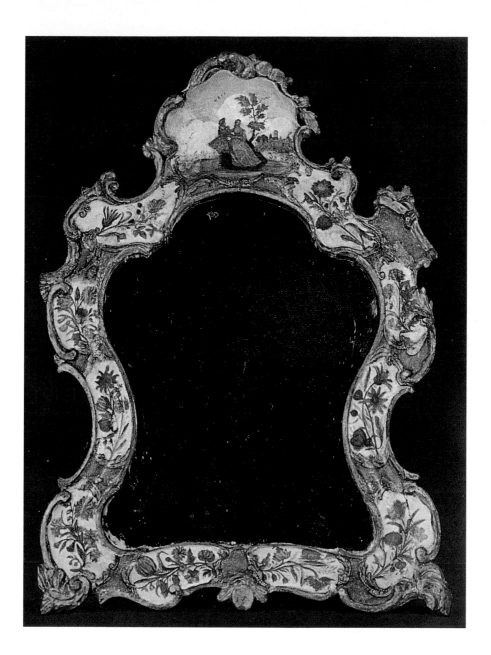

Mirrors were in great demand in the 18th century, aptly known as "the age of the looking-glass." The handcolored prints on this asymmetrical frame flow gracefully within its contours.

The box is another example of arte povera, with military figures and striping to accent the shape.

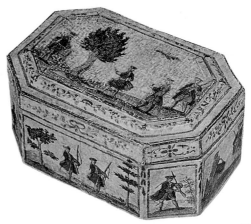

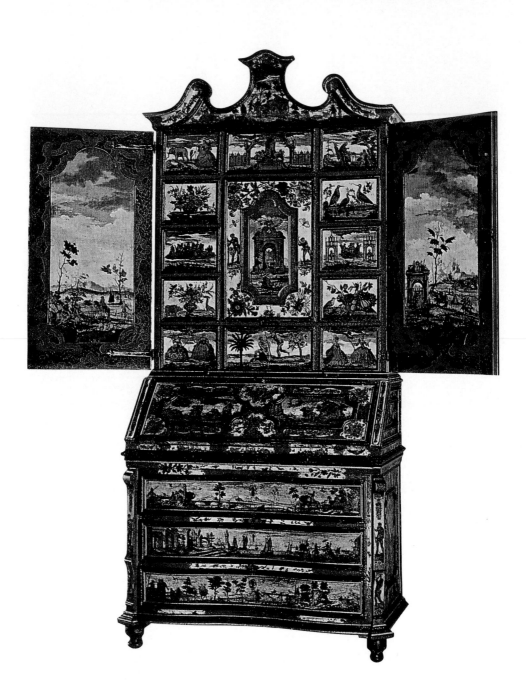

This dramatic early 18th-century Venetian lacca contraffatta *secretaire* (bureau-trumeau) *is a rare example of strong colors and bold execution. Striking red cartouches surround the découpage on painted landscapes bordered in blue faux marble. A three-drawer* desk is combined with a high cabinet (cassettone) *containing many panels, drawers, and often secret compartments to hide documents. In contrast, much larger-scale prints are visible when the mirrored cabinet doors are open.*

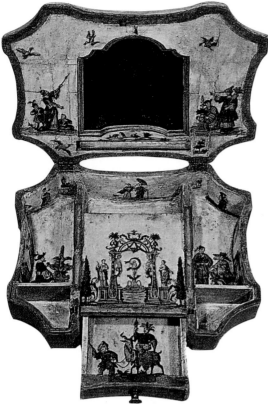

Graceful mid-18th-century Venetian vanity box with gilded and lacquered exterior. The interior may represent a fairy tale of exotic chinoiserie *set in an enchanted garden.*

Truly a masterpiece of coloring, cutting, and composition, this tall scriban *resembles delicate Venetian lace. Such 18th-century* lacca contraffatta *with carved and gilded trim was surely accomplished by the most skilled artisan in each Guild. The composition merits much attention: intricate lacy borders defining the spaces, curved garlands echoing curved architecture, a balance of figures and scenes similar but not the same. The doors open to reveal a cinnabar interior, also exquisitely découpaged.* Arte povera *indeed! It's worth a king's ransom!*

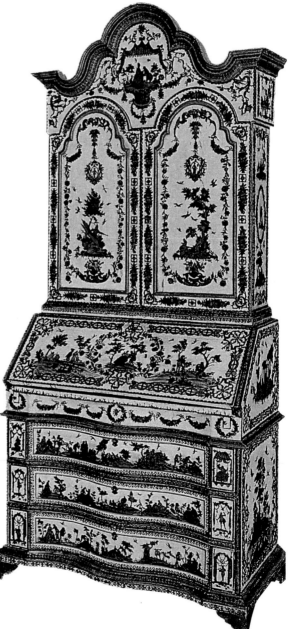

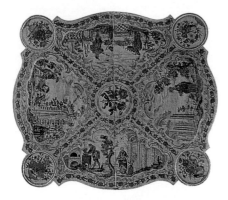

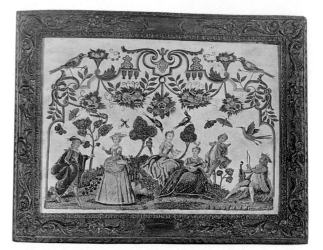

A rare example of arte povera, *this small picture was executed on a parchment background. Note the composition and delicacy of cutting and coloring for this romantic garden scene—all very harmonious.*

Gaming was a popular diversion in the 18th century. One of many, this gaming-table, inscribed 1756, is elaborately découpaged with polychrome engravings. The unusual composition in the round features different rustic scenes for each player. Scroll frames and rose borders lead to each of the medallions, while flowers even curve on the carved feet.

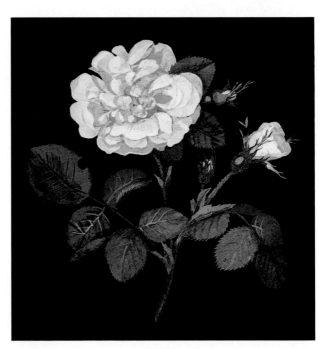

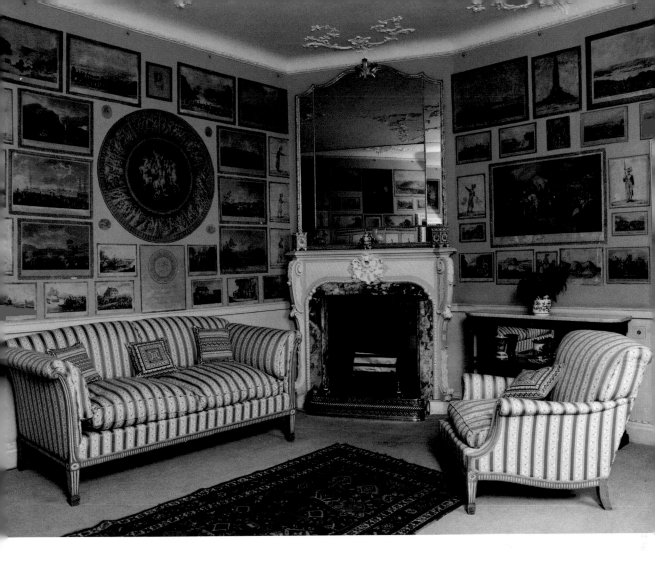

Mrs. Mary Delany, at the age of 74, made this "paper mosaick" (opposite, below) of the "Rosa Gallica var. Blush Rose," one of almost 1000 she created between 1772 and 1782. The veins are detailed on the leaves; even an insect bite is cut out of one. Literally hundreds of pieces of cut paper provided botanically accurate specimens. The lifelike shading of every petal, stem, and stalk was cut from paper, which Mrs. Delany had to dye or paint if she could not otherwise obtain it in the precise color. She would sometimes go to the docks to buy colored papers from sailors returning from the Far East. Frequent gardening and expeditions to collect wild flowers and herbs contributed to her unique and exquisite botanical artistry.

One of the Duke of Wellington's print rooms at Stratfield Saye, Hampshire, in which many pictures are closely placed in a rather severe style. The symmetry of so many evenly spaced horizontals dramatically contrasts with the large circular Wellington shield.

To plan your own print room, first take careful measurements, sketch the size (to scale) on graph paper, and make a diagram of your composition. To antique prints, wipe with cold black coffee or tea. Then hang the prints on the wall with temporary adhesive, making adjustments if necessary. Glue large prints by "wet-mounting" (see under "Gluing" in Chapter 6), then the frames, ribbons, etc. Apply several coats of finish with a large roller to protect your "gallery."

"A box is a vessel that can contain a fantasy world," said Rita Pressman Shaw. Her *interpretations follow:*

Gina's Box. *"A collage of my daughter Gina's old photos, paper, pictures. Also mirrors that reflect the sparkle of lighted bulbs."*

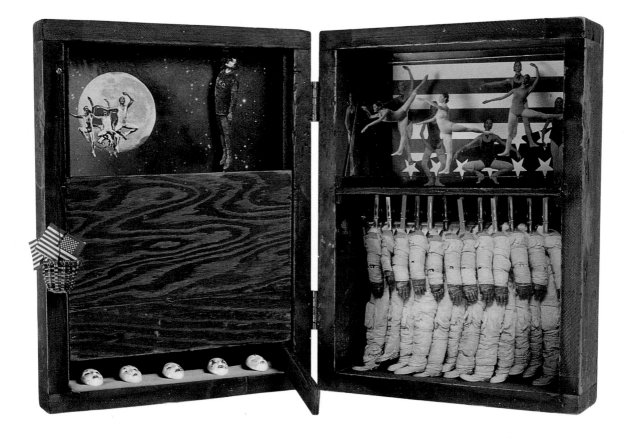

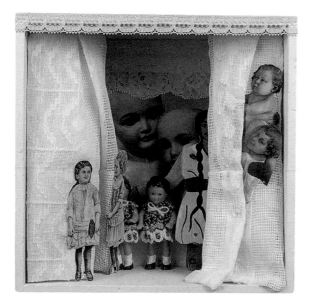

Astronauts. *"Spatial relationships and planes exist in a confined space that opens like a book. The chorus line of astronauts create movement which the ballet dancers repeat."*

Angels I. *"White denotes purity. Contrasting images of dolls and children are visual metaphors of interpretation."*

Technically, many different glues are necessary. Small objects are held in place with silicone seal.

Identical lap desks in different styles. Note the variations both in the spaces between the anemones and in their height. The flowers were glued, then cut through across the opening on these and on the humming-bird box.

Antiquing mellows the TV and VCR stand made by Wendy Brainerd's husband, which she then harmonized with easy-to-cut birds and blossoms. I antiqued the frame before circling it with handcolored engravings.

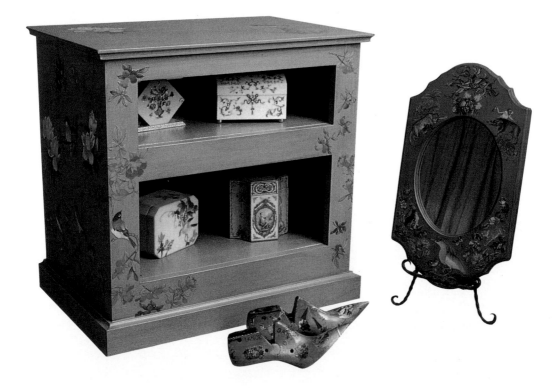

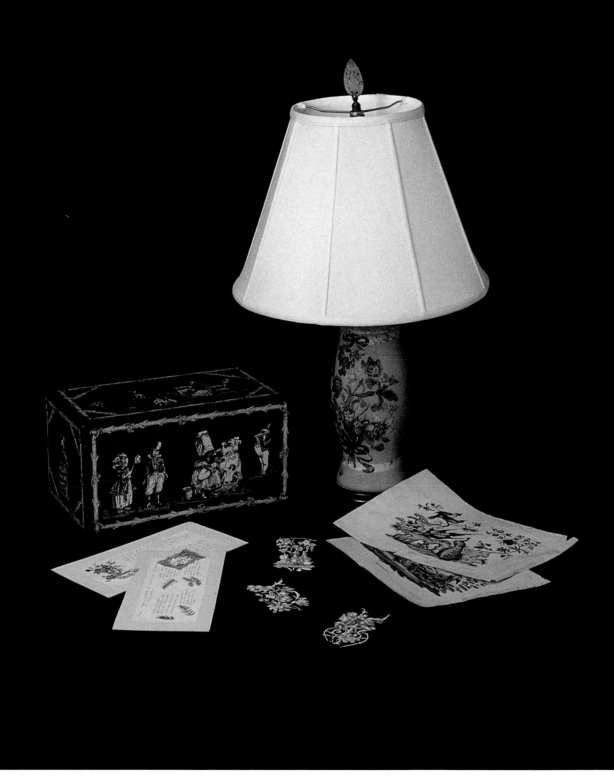

Your palette is your choice when handcoloring with pencils or paint. On the right are antique handpainted engravings from the Album du Poticheur. *The lamp is banded with French marble paper. On the left are reproductions handcolored with pencils. For the large box, Christopher Burton made colored copies of the curious anthropomorphic animals of Grandville (Jean Ignace Isidore Gérard), the 19th-century French graphic artist and political caricaturist.*

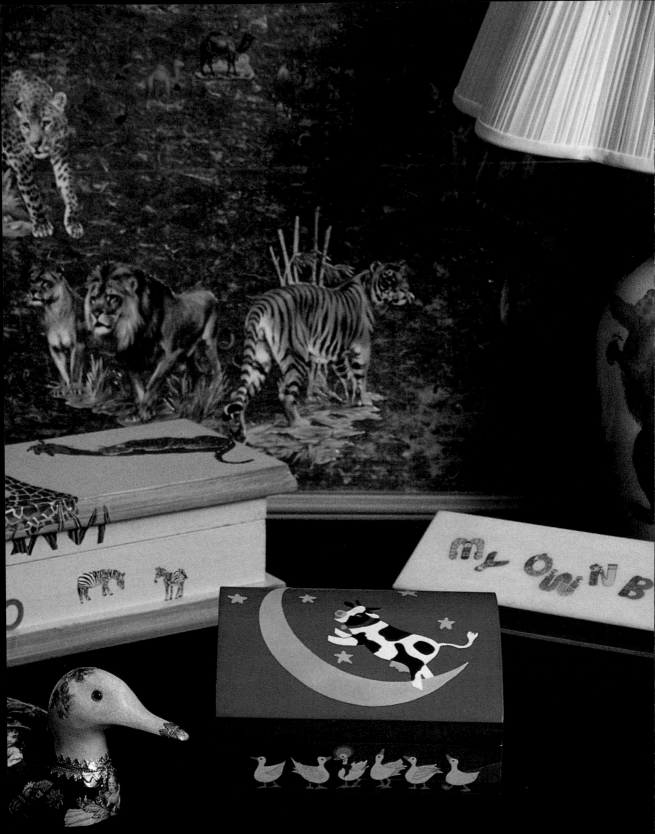

No problem finding prints for animal lovers! My granddaughter Amy painted the stars and flowers, while farm animals cavort around and inside the blue box (opposite). The duck decoy sports antique scrap and gold-braid trim. Wendy Brainerd découpaged the jungle animals for her grandson Antonio's box; and also the bed tray with African animals on a rice-paper background. Amusing monkeys are seen on Annamaria Crossfeld and Marie Jose Claro's potichomania lamp.

Patricia Nimocks's magic scissors created this winter wonderland of "glorified snowflakes" (her phrase) dancing for the Snow Queen and the Princess.

Below them, three generations of one family: "Ricki"'s small portrait done by his owner, Sister Parish; her daughter Apple Bartlett's very first piece of découpage, c. 1960, in the white frame; and granddaughter Susan Crater's dogs and flowers on plates and hanging holders.

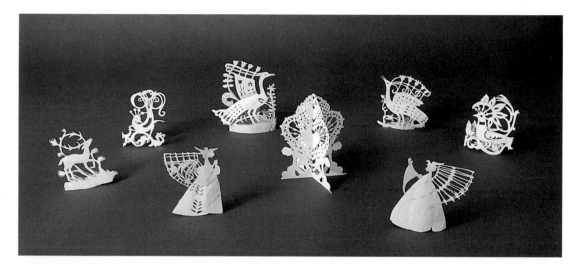

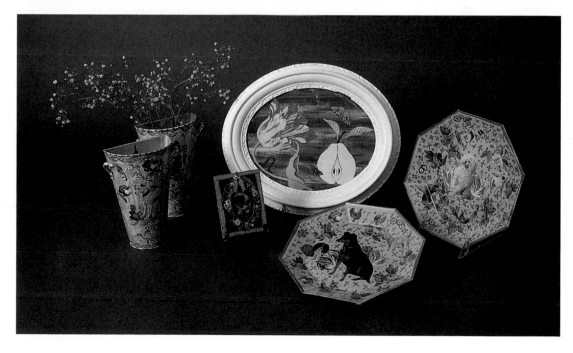

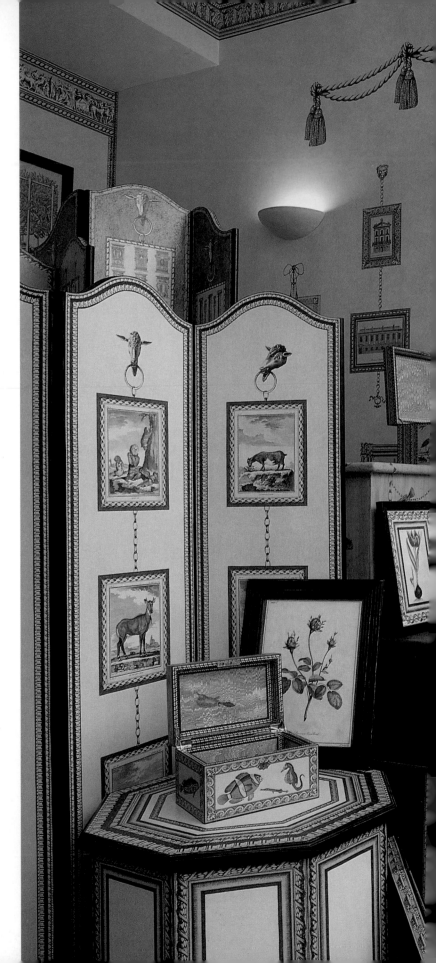

The tasteful London shop of Nicola Wingate-Saul where, she says, "We are still making print rooms such as were popular and fashionable in the 18th century, using original 17th- and 18th-century engravings. The cost can be cut dramatically if reproductions are used, and once stained in tea would convince all but the expert." For the decorated boxes, trays, etc., prices begin at £230 (about $350), before tax.

Inspired by this marvelous old idea, we take from it, add to it, and create something different. Being an avid découpeur, I added my scissors art, adapting it to that of the print room. This new look pleases me very much and has become extremely popular.

You, too, can readily adapt this technique to suit your own taste and decor. Browse through that collection of prints you've saved, and you'll find a theme. They don't have to be black-and-white—color prints are just fine. Animals, architecture, astronomy, astrology—it's limitless. Combine family snapshots with the subjects' hobbies, professions, pets, or sports in a wonderful personal mélange.

Skilled at faux finishes? Then softly sponge or strié the background. A small patterned wallpaper could work—some have lovely coordinated borders. How and what you put together makes it uniquely yours.

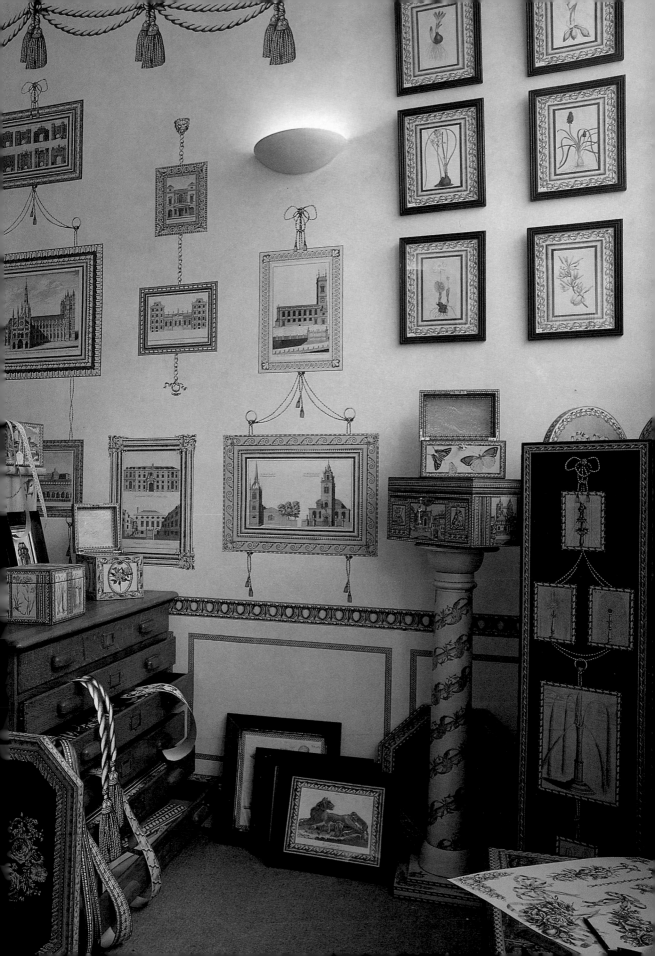

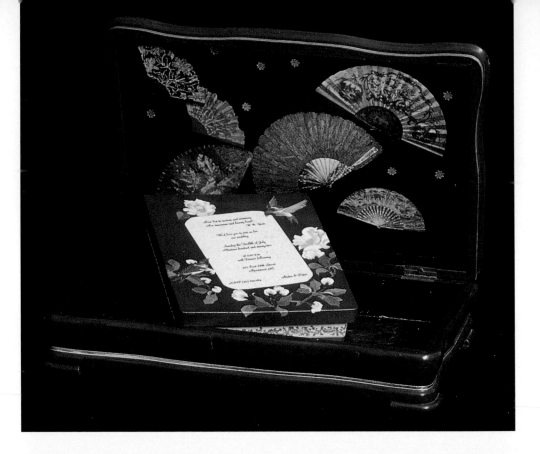

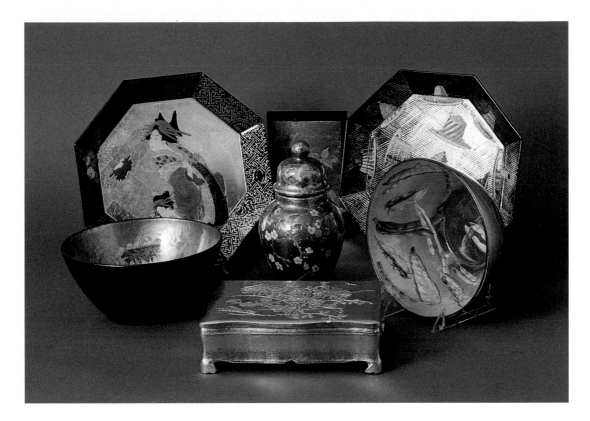

Capture a special occasion permanently and you have a family heirloom. I wanted a memento of Andra and my son Peter's wedding, using their invitation and color scheme (opposite, above). The découpaged flowers harmonize with the border banding the box and the hand-marbled paper lining. The invitation can be cut to appropriate size, or you can tear a deckle edge all around. Here, I painted a pink edge, then coated both sides with matte medium (see "Treating Special Papers" in Chapter 3).

Eirene Herd recycled the large silver chest with reproductions of antique fans. This is not a static composition, even though the shapes are all similar. Gold paper rosettes and braid are the finishing touches.

And yes! That's ordinary brown wrapping paper cut in geometric shapes. A contemporary look seemed appropriate for this inexpensive glass jar (opposite, below) then the surprise: combine it with silver leaf.

The elegance of gilding enhances the art of many styles of découpage (above). Lois Silberman's expertise is evident on the gold and silver box. Its soft Italian wood necessitated much well-sanded gesso; the detailed print was raised in repoussé, then leafed. The Japanese lady on the octagonal plate is one of Lois's set of eight different prints with oriental paper borders and finished in silver leaf.

Many boutiques are selling Donna Lieb's potichomania bowls and plates. The prints are handcolored, and sometimes metallic waxes are applied before gilding. Then painting over the leaf makes the bowl's exterior strikingly different from the interior.

Veronica Voelkle antiqued the glass ginger jar before gilding.

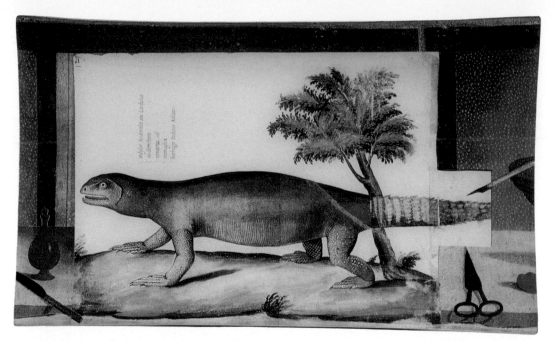

If you see a striking piece of découpage in the shops signed Willan F., you'll know it's the work of Ann and Willy Francois. It's "the outcome of a successful collaboration between France and America represented by their husband and wife partnership." Both studied at art schools, he in Paris, she in Manhattan, and both know and love animals, art, and designing. Their "artworks of découpage on glass and wood for the commercial marketplace," Ann said, started by making gifts together for friends and family. Mainly their pieces are one of a kind, though occasionally they'll do a numbered limited edition. They reach back, taking old designs and images from long ago to re-create them into a contemporary, almost Surreal, style.

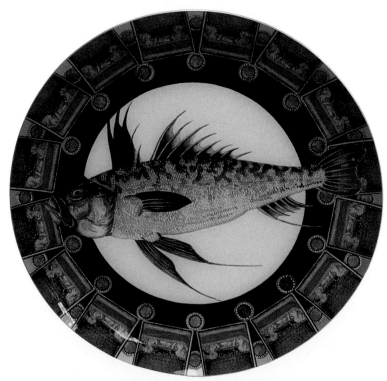

The "cordylus" lizard, done by an unknown artist c. 1500, is composed with various papers to make a trompe l'oeil picture. Notice that the red of the flask on the left is repeated much smaller on the right of the 12 × 20 in. (30 × 50 cm.) plate. Notice, too, the tools, leading into the composition.

Such an ugly fish, and yet it makes a handsome plate. The "dragonet" fish and border are both 15th century. Ann and Willy laser-copied the border from an Italian Tarot card, but it looks like Art Deco. The glass plate is 18 in. (45 cm.) in diameter.

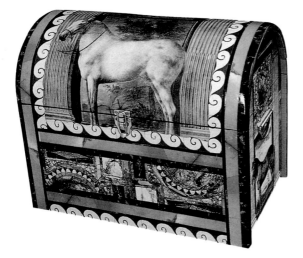

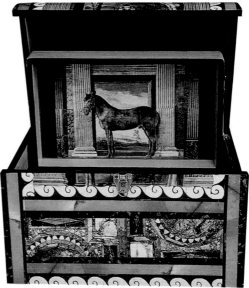

Two different treatments are given to this wood trunk measuring 23 × 13 × 23 in. high (58 × 33 × 58 cm.). The inner trays are découpaged under glass (one shown upright, with the lid of the trunk open).

The Barbary horse standing between fluted pillars on the closed lid comes from a 15th-century Italian painted fresco. The borders are from reproductions of Roman marble pavements, c. 3rd century AD, found in an old book.

The Grand Canal in Venice has inspired many painters, this one of the late 15th century. The marble columns and balustrade place you on the balcony. The fascinating architectural arrangement repeats the railing vertically on both sides of the box. Turn the picture upside down and you'll recognize the typical Venetian columns.

Postage stamps provided the decorations for
Ruth Lipston and Joe Staino. Every time Ruth
wears her purse, someone wants to buy it right
off her arm.

Joe made several mementos with a theater
program, matchbook covers, and a U.S.
commemorative bicentennial stamp.

Like a ray of sunshine, this bombé chest
(described more fully in Chapter 8) brightens
the foyer in my apartment. Ann Huntington's
firescreen on page 127 uses the larger flowers
and birds cut from the same handpainted silk
Chinese panels.

Ettore Bottoni had these miniature Persian illustrations enlarged before handcoloring and composing his masterpiece screen. The background is Japanese gold paper. The images are from a late-16th-century copy of the great Persian epic The Book of Kings (Shahnama), *published by The Metropolitan Museum of Art, New York.*

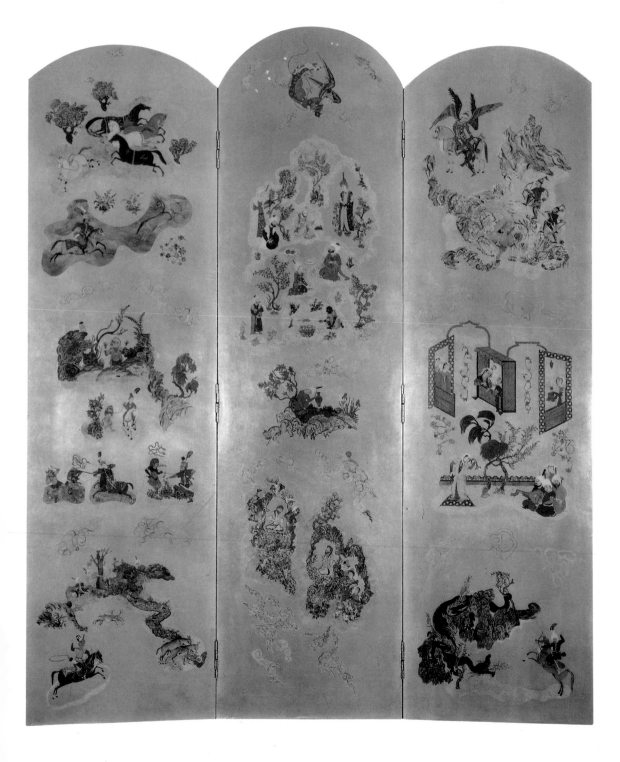

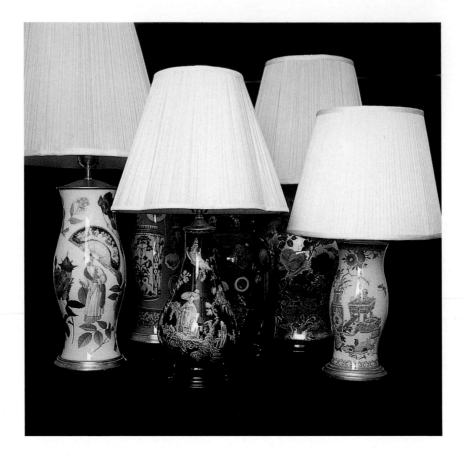

An abundance of beautiful potichomania by John Campbell, Mercedes Fernandez, Edward Schaefer, and Lois Silberman. All, except Lois, are selling these for $1,000 (about £650) and up, without the shade. Prices increase according to the quantity and quality both of the prints and of the intricacies of the cutting. Bases and caps are either wood or metal, often painted or gilded.

I copied Robert Sayer's book The Ladies Amusement (shown open, opposite) for the lamp and plates, a variation of the print room style. Rustic garden seats, gazebos, and temples are accompanied by the usual garden variety of animals. Marbleized gold leaf glows through the cherubs (on thin paper) on John Noble's box.

Fresh paint restored the old baskets (opposite, below), which were then decorated with cut fabric (see Chapter 3).

I cut flowers, from leftover drapery fabric, to circle around the hurricane shade (one of a pair). At night, candles burning safely inside the rings of flowers make a festive dining-table.

Small fruits take the place of numbers on the octagonal wall clock with a centerpiece of fruit. You can make a clock out of almost anything, as long as a hole can be drilled in the center for the shaft of a quartz clock movement.

The Shaker basket with geraniums on the lid had a color wash of thinned-out apricot paint applied, then wiped off immediately to leave the wood grain visible. It is lined with a miniature dollhouse wallpaper, also with geraniums.

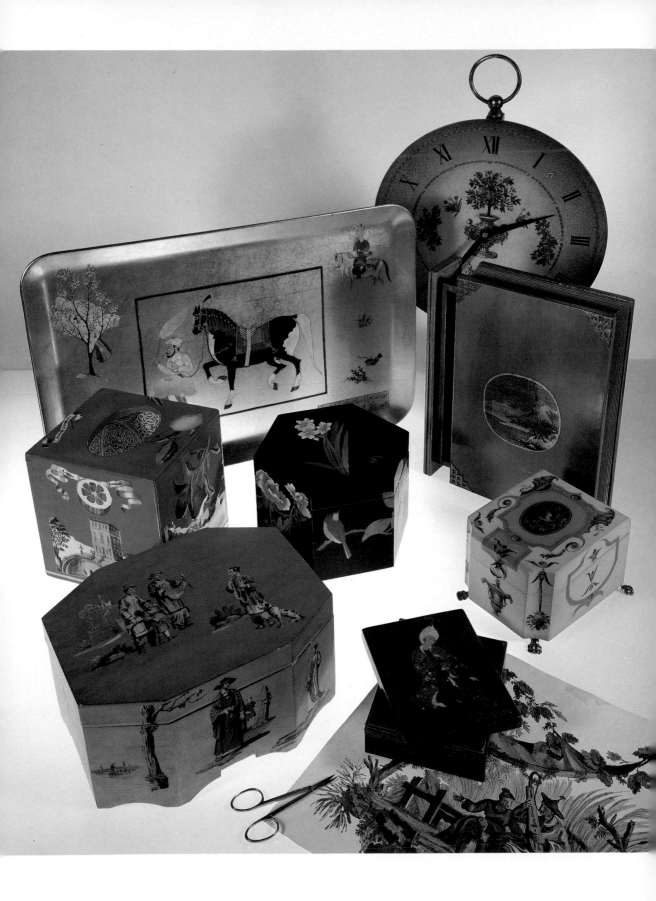

THE VARIETY OF SUPPLIES

Think of it as one continuous adventure when you're treasure-hunting for supplies. The more you *look*, the more you'll *see*, the more you'll be inspired—styles, colors, textures, and details you never noticed before. You become aware of all the parts of the whole; you are consciously developing the artist's analytical eye. Ideas come from anyplace and anytime, so be sure to jot them down for future projects.

CHOOSING PRINTS

There is a limitless assortment of prints on paper that you can use, and the paper itself has many different qualities and weights. First, try to avoid papers that could cause problems, such as thickness, glossy coatings, and runny inks. You need good-quality paper of medium weight: if too thick, it is hard to cut; if too thin (usually inexpensive), like newspaper, some magazines, and wrapping paper, it is not made to last, but will fade and disintegrate. Avoid textured papers; flat paper glues down better and coats more evenly. Glossy coating, such as a magazine cover, does not bond with, but repels the final finish coat. Most inks are permanent, but don't use any print that runs or smears when you spray-seal it (see Chapter 6). Practice cutting with different papers; after a while you'll be able to judge the suitability just by the feel of it. Papers with any of the above problems can be taken to a good copy shop to be reproduced in color or black-and-white. Be sure to check any questions of copyright when making reproductions for découpage you plan to sell.

Good sources for prints are print shops, craft and hobby shops, bookshops, and museum shops. Then there are calendars, greeting cards, auction and other catalogs, portfolios, and posters. Many bookstores have "remainder" books on sale—art books, children's books, books of flowers, seashells, birds, even fashions—all with good color illustrations.

A collection of pieces made in the seventies, which I am still using. The clock and small Persian box are crackled and antiqued. Reproductions of charming 18th-century Volckamer prints brighten up the tissue box. Notice three separate paint colors on the miniature knife box.

Prints for a beginner's project should have simple well-defined shapes, not a lot of details. As you practice cutting, the more you will improve and the more enjoyment you'll have. Save the more intricate and delicate (such as Pillement) prints until you feel competent and ready to tackle them. Buying two of an inexpensive print allows you to experiment with cutting out, and to test a new material or technique, and still have a spare in case of error or accident. A word of advice: gather *more* prints than you estimate you'll need. After you've cut all the background away, you may not have enough left to complete your project. If you have too much, you can always use it elsewhere. It is very frustrating to run out of prints in the middle of a composition. More often than not, I find myself adding to, rarely subtracting from, my cuttings when I'm composing.

Store your print collection flat in dust-free plastic bags. Store your cuttings in the plastic pages of a photo album to keep them in good condition. This way you can *see* at a glance what you have without handling or damaging them. Save your memorabilia, snapshots, tickets, programs, greeting cards, stamps, wine labels, and seed packets. They'll come in handy for a special-occasion present.

COPING WITH PRINT PROBLEMS

Changing Colors

The colors in a print can be touched up or changed with permanent oil pencils or diluted acrylic paint. The pencils are available in every shade of every color and can easily be erased. Use them to brighten, lighten, tone down, and shade. With a little practice, the eraser won't be used often. Use a light to medium pressure, keeping the shading transparent and allowing the print details to show through on a black-and-white print. On a colored print, blend your colors with the existing inks. First check the pencil color on the side of the page, then add colors in several layers for intensity. Lighten a color by erasing some of the dark inks, then coloring over the area.

Blocking out Printing on the Back

Test pictures that have printing on the back to make sure that it will not show through. When the sealer on the front is dry (see Chapter 6), hold the picture up to the light and check if you see printing in the area to be cut out. If so, place the picture face down, erase as much print as possible, lightly sand, wipe off, then cover with a coat of opaque white paint. When dry, hold it up to the light and see how well the trick worked.

Thinning Thick Paper

Thick paper does not usually lend itself to fine cutting and its cut edges will be bulky. You can thin it by peeling off several layers at one time. To do this, spread a fairly thick coat of white glue over the back of the paper and let it dry completely. With the tip of a sharp knife, split and peel up a corner of the paper. Roll this corner around a pencil as you peel off a layer, holding the print firmly with the other hand. If it breaks off, start again at another corner. After peeling, sand the back smooth with a fine sandpaper.

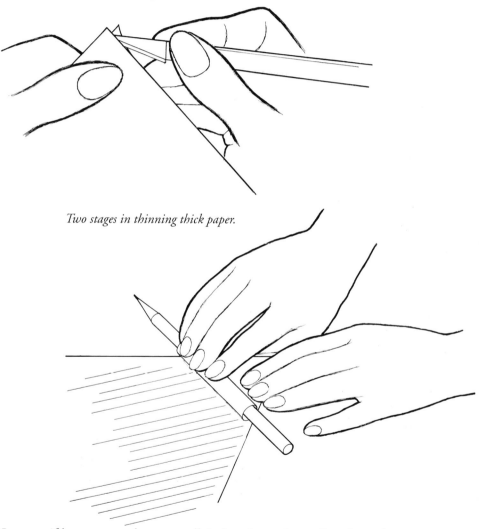

Two stages in thinning thick paper.

However, if heavy paper does cut well, it doesn't require peeling. It can be spray-sealed *after* cutting out in order not to add to the thickness when cutting. Place the cutouts in the bottom of a box lined with foil; then, to keep the papers from flying around, lightly spray from a distance.

Handling Thin Paper

Thin paper may wrinkle up while gluing. This can be avoided by giving more body to the paper: first seal the front; then, before cutting, coat both front and back with matte artists' medium. Dark backgrounds will shade through thin paper: to avoid this, coat the back with opaque white paint before coating with the medium.

Treating Special Papers

Engraved invitations and birth and wedding announcements on parchment require special treatment to avoid "spotting" of the paper. To keep these remembrances safe, coat the front and back with matte medium, allowing each side to dry thoroughly. Use the same treatment to preserve precious antique engravings when the paper is old and tender.

Wallpaper does not lend itself to cutting out—it is too thick and pulpy. However, it is fine for lining or covering boxes and wastebaskets.

To include snapshots with a découpaged piece of memorabilia, the photos must have a matte, not glossy, finish. Brush a coat of matte medium over the front of the photo; peel some layers off the back or sand it down to reduce the thickness. Be sure to color the white edges with paint or oil pencils. After gluing, burnish the photo's edges as flat as possible before coating with finish (see Chapter 6).

SURFACES

This too can be an exciting treasure-hunt—any surface, any object can be découpaged. True, you can't make a silk purse out of a sow's ear, but you certainly can transform an ordinary object into an *objet d'art*. Look around the room you are in right now and see if any of the things in it could be improved with some decoration. Let your imagination go and the ideas will flow freely. There are things in the attic, basement, and garage, things tucked away on shelves and in closets (too good to throw away) that are adequate to start working on. Surfaces, old or new, wood, tin, glass, plywood or MDF (medium-density fiberboard), ceramic, plastic, greenware (unfired pottery), papier-mâché, leather, stone, etc., etc. They all work.

There are craft and hobby shops that carry new raw-wood boxes, plaques, tinware, etc.; gift shops that have glass plates and hurricane shades; antique and secondhand shops and flea markets that have old wood, tin, and glass decorative and functional accessories and furniture. Maybe you are lucky enough to have a friend

who does woodworking and can make exactly what you want. Some suppliers have mail-order catalogs.

If you are a beginner, start with a simple piece with a flat surface, such as a tray, plaque, bookends, or hand mirror. Leave the grand piano until you've learned the necessary skills; and wait a while to do doll-house furniture, because cutting out small-scale prints requires extra skill: it takes practice and experience to tackle larger projects, miniature pieces, and complicated shapes. Meanwhile, you'll develop self-confidence with each successful piece of découpage, after which you'll enjoy the challenge of more intricate, advanced projects. It's going to take some time, anyhow, to decide on the appropriate style for the piano and collect all the necessary prints!

SUGGESTED OBJECTS TO DÉCOUPAGE

For the living room: screens, boxes, coasters, planters, plaques, ashtrays, vases, music boxes, lamps, frames, clocks, and tilt-top tables.

For the bedroom: tissue covers, jewelry boxes, quilt racks, hand mirrors, and waste-baskets.

For the dining room: placemats, candlesticks, napkin rings, trays, plates, hurricane shades for candles, and chairs.

For the kitchen: cabinet doors, stools, recipe boxes, garbage cans, doorstops, towel racks, and picnic baskets.

For the library/office: letter trays, paperweights, bookends, stamp boxes, pencil holders, footstools, decoys, and baskets.

On special occasions for friends and family: wedding and birth announcements, and memorabilia for birthdays and anniversaries.

Just for fun, I découpaged daisies and ribbons around her cane for a friend with a broken leg; she now has an entire wardrobe of canes to match various outfits. I decorated a motorcycle helmet with hot-air balloons for a client, but I balked at doing his motorcycle, too. I made it rain cats and dogs inside a clear plastic umbrella. My kitchen looks more cheerful with tulips around the garbage can. I couldn't resist the brightly colored Matisse-shaped birds from a Christmas card, and they now float around on a mobile. Morning glories ring the toilet seat in the

powder room and never fail to get compliments. For a friend who has everything, I découpaged tiny oriental figures on both sides of an agate slab, and it's been on an easel on a living-room table ever since. An old milk can and a metronome are waiting for me now, but I haven't decided yet—enough!

DÉCOUPAGE WITH FABRICS

That extra fabric left over from the drapes or slipcovers is just the thing for découpaging accessories. Tightly woven fabric that won't ravel, like cretonne or chintz, is best for cutting out. You can match wastebaskets, lamps, switchplates, placemats, baskets, and lampshades to your decor. Fabric has more body than paper and usually the patterns are less detailed, so it's easy cutting. If the fabric is not treated to resist soil, spray-seal the front twice with acrylic sealer or a fabric proofer, such as Scotchguard. Brush on a coat of matte medium over the back of the fabric and let it dry thoroughly. This keeps the edges from raveling when cut. If a thread loosens, snip it off. Glue the fabric to the surface with matte medium. Use a plastic spoon or burnisher to press the fabric to conform to the reeds of a woven basket and attach it firmly. Optional: coat the entire surface with matte medium to protect it from dust and dirt. If the piece will be subject to hard use, then coat with a hard finish. Fabric can also be glued under glass (see Chapter 7: Potichomania).

JUST FOR FUN WITH CHILDREN

Quick and easy is best when working with children. They are very creative and uninhibited—here the goal is having *fun* making things. Découpage without tears should not demand much patience or perfection. Try to use inexpensive surfaces and ones that don't take much preparation. Do have some permanent markers for them to add a stripe or polka dots, or sign their names. Matte medium will suffice as both glue and final coating (see Chapter 6), since it is water-soluble and dries in about twenty minutes. Smooth rocks with a clean surface make fine paperweights after you put felt on the bottom. Colorful candles and flat bars of soap look pretty decorated with flowers or Victorian scrap pictures. Girls like plastic bracelets and barrettes; boys like keyrings. Decorate a clay flowerpot or a small plastic waste-basket, container, or box. Prepare an assortment of simple prints for easy cutting, so the children can make their own choices. They'll enjoy cutting out pets, flowers,

initials, sports motifs, zoo animals, fruits and vegetables, Beatrix Potter and Kate Greenaway figures, mementos, ships, cars, trains, movie stars, etc. Find these in magazines, wrapping paper, party paper napkins, postage stamps, comics, even snapshots; recycle greeting cards.

It's easier to handle a group of children if you designate a theme such as the Circus, the Farm, or a Holiday. Halloween, for example, will give them a choice of ideas from pumpkins to witches.

We all treasure the keepsakes a child has made by hand—especially for us. Encourage such creativity and you will all have a memorable, delightful time "playing" together. Since she was a tiny, my granddaughter Amy has made birthday and Christmas presents for parents and relatives and teachers. She was so proud of her handmade gifts and everyone was surprised and pleased. Recently, at the age of fifteen, Amy was inspired by a print of the cow jumping over the moon (see page 44). She handpainted the stars, the fence, and flowers to round out the story told in découpage. Most important, she has learned skills, gained knowledge, and found true enjoyment in her artistic endeavors.

TOOLS
AND MATERIALS

Shopping for your tools and equipment will take you to art and craft shops, paint merchants, DIY and hardware stores, finishing suppliers, and perhaps lumber (timber) yards. It's best to begin with just the basic necessities; don't buy everything in sight. As you work and learn, you'll develop preferences for certain products. Wherever possible, I've suggested substitutes that work adequately. Where terms or brand names differ between the U.S. and the U.K., the equivalent is given in parentheses.

TOOLS

Scissors Buy the best quality available: Solingen steel with narrow curved blades and slender points (cuticle scissors) for your own exclusive use and only for découpage. Any straight scissors will do for cutting away excess paper.

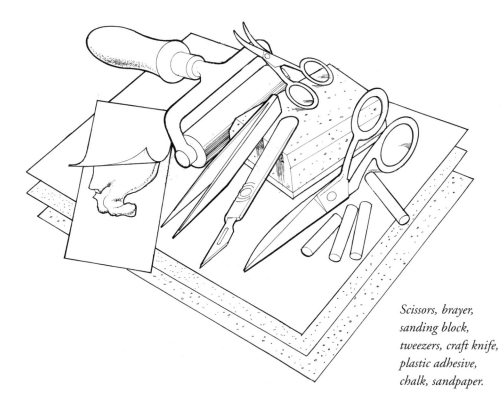

Scissors, brayer, sanding block, tweezers, craft knife, plastic adhesive, chalk, sandpaper.

Brayer (Roller) A small rubber printing roller, about 4 in. (10 cm.) wide, with handle, used to press out excess glue and air bubbles. Substitute: a smooth round glass, bottle, or pencil.

Burnisher A 6-in. (15 cm.) leatherworker's tool with a curved paddle end used to bevel and flatten the edges of prints after gluing. Substitute: an orangewood manicure stick, cuticle pusher, or bowl of a very small spoon.

Craft knife A small sharp-pointed knife to cut out tiny areas. Substitute: razor blade or scalpel.

Art pencil sets Colorfast and oil-based, these are used to add color to prints and edges of cutouts. Substitute: acrylic paints.

Plastic adhesive A removable and reusable adhesive, such as Hold-It (Blu-Tack). It is a pliable, puttylike substance that holds cuttings in place while designing. Substitute: drafting tape.

Brushes High-quality synthetic brushes are recommended, and can be used with *all* types of paint and finish. Use separate brushes for paint and varnish and mark accordingly. Use a 1-in. (2.5 cm.) brush for small surfaces and larger sizes for larger

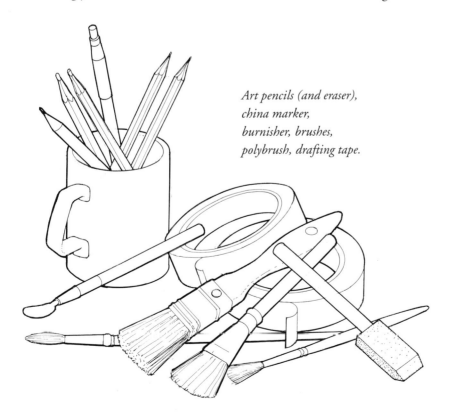

Art pencils (and eraser), china marker, burnisher, brushes, polybrush, drafting tape.

surfaces. An inexpensive ½-in. (13 mm.) glue brush is helpful, or you can use your fingers instead. Natural-bristle brushes are expensive, and should *only* be used for oil-based paint and varnish. With proper care, good brushes will last for years. Foam-sponge applicators (polybrushes) are excellent, inexpensive, but short-lived. They won't show brushstrokes, but can cause air bubbles if you press down too hard. After using, place in solvent immediately, then clean thoroughly with soap and water, wash, rinse, and reshape. Store brushes with the bristles upright in a container, or lay flat.

Paint rollers As rollers leave no brushmarks, they are perfect for the final, smooth, even coat of paint. A useful 3-in. (7.5 cm.) roller comes with its own tray. Buy short-pile, not textured, replacement roller covers as well.

China marker A grease pencil used on glass to outline prints. Substitute: wax crayon or eyebrow pencil.

Colored chalk Use chalk to mark the painted surface where cutouts will be glued.

Sanding block Wrap sandpaper around a wood block padded with felt to sand wood surfaces level. Substitute: felt eraser or small, flat rubber eraser.

Steel wool (Wire wool) The finest grade (0000) is used to polish varnish satin-smooth. Also used to smooth paint, but might discolor light colors.

Tack cloth Cheesecloth, sticky with varnish, to wipe away dust and sanding residue. Keep in a tightly closed jar or plastic bag. Always clean the surface (tack) before every coat of paint and varnish.

Paint roller, steel wool, tack cloth.

Long tweezers Used to pick up and place tiny cutouts on the surface while composing and gluing.

Sandpaper (Glass paper, Flour paper) 9 × 11-in. (23 × 28 cm.) sheets coated with abrasive particles varying from "very coarse" to "ultra-fine." The higher the number, the finer the paper. Garnet (orange) gives the smoothest finish to raw wood. "Wet-and-dry" silicone carbide is used to smooth paint and varnish.

Drafting tape Use to mark box for hinge placement. Holds box and lid together. Substitute: masking tape or white artists' tape. Remove tape as soon as possible to prevent paint damage.

MATERIALS

Modern technology has done wonderful things for découpeurs. Now we can accomplish in a week what used to take six. We get better results with safer, easier-to-use materials. Most water-soluble art and craft supplies are recommended for health, safety, and environmental reasons. When there is no substitute for a hazardous material, these "Safety Alert" steps are helpful: (1) Use an exhaust fan, even in a well-ventilated area. (2) Wear surgical gloves or barrier cream to prevent chemicals entering through the skin. (3) Wash your hands with soap and water before eating. (4) Wear a mask with a filter; if sensitive or allergic, avoid all toxic fumes. (5) Do not use if pregnant.

Read the fine print on the product label *before* you purchase; it will save you both time and money. The information should tell you if it suits your purpose, how best to use it, and the appropriate solvent. Buy a sufficient quantity to complete the project; changing products midstream can cause compatibility problems. The large, economy size is not always a bargain. Learn the "shelf life" of materials and how to store them. Follow the manufacturer's instructions on how best to work with that product.

PRODUCTS FOR WOOD

Wood filler Use to fill deep holes and cracks in old and new wood.

Vinyl spackling Fills in dents, shallow areas, and crosscuts (cut end of grain that will never sand smooth).

Shellac (Button polish) Diluted half shellac, half denatured alcohol, seals old or new wood before painting and prevents any resin or dye bleeding through the paint later on. Shellac or knot sealer must be used to cover knots in raw wood.

Sanding sealer Used on raw wood to fill in the grain before painting. Easy to sand, and gives the smoothest result with the least effort.

Primers
Undercoat: Fills in pores and wood grain and reduces absorbency; seals surfaces and aids the bonding of the top coat. *Acrylic gesso:* Hard to sand, but results in a silky-smooth, non-porous surface.

PRODUCTS FOR PRINTS
Sealers Applied before cutting to protect prints from damage and finger marks. Will also protect painted surfaces.

Clear acrylic sealer Solvent-based and comes in spraycans. Used extensively for protecting artwork on paper.

Matte medium A liquid acrylic copolymer emulsion that dries quickly to a clear film. Serves as a protective coat for both paper and paint, and is also used to glue paper. Water-soluble when wet. Dried medium can be removed with hot water, but a dab of denatured alcohol might be needed for stubborn bits.

Clear shellac Available in spray and liquid form. Must be worked quickly with a brush, as it dries very fast.

GLUES
White craft glue Comes in various strengths and consistencies for use with paper, cardboard, and fabric. It is water-soluble; dries clear but shiny, so any excess must be removed.

Spray adhesive Sometimes used for gluing linings; not recommended for gluing prints. It is difficult to get exact, even coverage, requires a strong solvent to clean, and may loosen under multiple coats of finish.

Yellow wood glue Aliphatic resin, provides the most permanent glue for wood repairs. It is slow-drying and solvent-based.

PAINT (EMULSION)

Liquid paints, variously called acrylic, latex, and vinyl, are recommended. They dry quickly, are odor-free, and clean up with soap and water. Water-based paint comes in a range of sheens, from matte to glossy. Do not use high-gloss enamel, because it won't bond with glue or varnish and good adhesion is essential. When painting a large area, add a few drops of acrylic paint retarder or glycerine to slow drying time. Tube acrylics are not recommended for base coats, because they tend to show brushstrokes and create a textured surface. They can, however, be used for tinting water-based paint.

STAINS

Transparent colors that enhance and accentuate the wood grain. *Do not* seal the wood before applying a stain. Follow the manufacturer's instructions on the label and seal when dry.

PROTECTIVE TRANSPARENT FINISHES

For the final coatings, there is a variety of water-based acrylic and solvent-based varnish to choose from. You also have a choice of sheen, ranging from matte to high-gloss. New colorless acrylic finish is best for white and pastel backgrounds, when you don't want any color change. These new finishes go on milky, dry clear, harden quickly, and can be wet-sanded and polished. However, the surface film clouds the intensity of dark colors; for example, black lightens to a charcoal gray. Here, solvent-based varnish is best for dark color and gilded backgrounds, because it enhances them, giving them depth and patina. All varnish products have an amber color, but pale furniture varnish is preferred, as it is the lightest. High-gloss gives a more durable finish than low-gloss varnish. Most polyurethane contains too much color, is hard to sand and polish, and scratches easily. Lacquer is not recommended for brushing by hand. It dries so fast that the best results are sprayed professionally. However, a spray lacquer gives good coverage on baskets, carvings, and textures.

When uncertain about which finish to choose, try this exercise: cover a piece of clear glass with six coats of varnish; then hold the varnished glass over the découpaged piece to test the look, and your eye will tell you if the color change is pleasing.

It's a plus if the label tells you the liquid contains a UV inhibitor that absorbs the ultraviolet rays.

SOLVENTS

Denatured alcohol (Methylated spirit) The solvent for thinning shellac and cleaning shellac brushes. It is also used to clean grease and dirt off old pieces before refinishing. Also removes dried latex and acrylic paint.

Mineral spirits (White spirit) Turpentine or paint thinner are solvents for oil-based paint and varnish. They are used to thin paint and varnish, to clean brushes, and to clean dried paint.

PRODUCTS FOR POLISHING
These are used to obtain the final hand-rubbed patina:

Wet-and-dry sandpaper (medium to fine).

Steel wool (0000, finest grade).

Lemon oil (colorless), to mix with rottenstone and pumice powder.

Furniture wax (colorless).

Automotive polishing compound (liquid).

HOUSEHOLD SUPPLIES

Make a kit of the following and keep handy while working:

For cleaning up Paper towels, clean cloth or honeycomb cloth, cotton swabs, mild liquid soap, and small disposable plastic containers for water.

For cleaning glass Chamois and ammonia or white vinegar.

For gluing Small sponges, toothpicks, straight pins, colored chalk, roll of foil or plastic wrap.

For holding solvents Small glass jars.

For polishing Old pantyhose or stocking.

For stirring paint or varnish Craftsticks or chopsticks.

For sanding block Small flat eraser (rubber) or blackboard eraser.

Optional:

Magnifying glass for extra-fine cutting.

Miniature tool kit for applying hardware.

Plastic "lazy Susan" (turntable) to rotate and study composition.

Fan to remove fumes and clean air.

Center-finding ruler for hardware and print placement.

Radio or tapes of favorite music to work by.

YOUR WORK AREA

Organizing your work area makes it easy to operate efficiently. A clean cardboard carton holds supplies, and an old toolbox or new plastic art bin keeps small equipment handy. Good light is essential; an adjustable halogen lamp is the best. Your working surface should be level, clean, and dust-free. Cover it with brown wrapping paper or plastic bags from the cleaners; or cut plastic drop cloths into large squares. *Do not* work on newspaper, because the printing ink might come off. An extra cardboard carton inverted over your work will keep it dust-free while the project dries. Poke a few holes in the sides, so that the air can circulate.

Materials should be stored in a dry, not humid, area kept at an even temperature. Jars should be rotated occasionally, like wine. Cans should be closed tightly, by stepping on the lid, and stored upside-down. Keep left-over paint for touching up. Transfer it to a small jar to ensure that it won't dry out, and be sure to label it.

Keep a notebook with a dated page for each project. List materials, sources, prices, etc.—even the number of working hours. Include a snapshot of the finished piece. You'll find this helpful for duplication or for pricing your work. Add the cost of materials to charges for labor. A photographic record is a good way to judge your progress.

BEGINNER'S BASIC KIT

simple wood project	scissors
sealer	glue
sandpaper	tack cloth
0000 steel wool	paint brush
paint	finish brush
prints	finish

5 PROGRESSING CREATIVELY

"Every work of a skilled . . . artist . . . is shaped by an absolutely unique combination of personality traits, creative abilities and individual . . . experience. . . . No new work of art comes into existence (whether consciously or unconsciously) without an organic link to what was created earlier." Alexander Solzhenitsyn, address to the National Arts Club, New York, January 1993.

CUTTING, COMPOSITION, AND COLOR

Your creativity expands while you learn the necessary techniques—like a chain reaction. Talent and creativity can *not* be measured or tested, but study and hard work will release that "hidden" talent. Suddenly one day you'll lose yourself in a state of "flow," with ideas spilling out and multiplying. The better you are at what you do, the more you are able to innovate and experiment. Start with simpler choices and ease into the more advanced challenges. You should move ahead when your skills balance the challenge. You'll never be bored when you immerse yourself in your artwork. I hope that the examples of découpage illustrated will inspire and stimulate your own abilities.

In *Drawing on the Artist Within*, Betty Edwards speaks of "unlocking the doors to perception and releasing the potential for creativity . . . the mind is focused and a moment of insight occurs." You'll "get the picture" at that moment of inspiration and intuition without rational thought or inference.

You will select, synthesize, and arrange many things to tell a story, depict a scene, create a period piece, or just to decorate. Putting it all together harmoniously should include seeing new ways of decorating and creating innovatively. Mainly, your choice of prints determines the appropriate style. The size, shape, and function of the piece must also be taken into account. Consider these options first: is it to match or coordinate with the decor in a particular room? Is the room an eclectic mixture? Should it be simple or sophisticated? If you carefully study the découpage pieces in

this book that catch *your* eye, you'll figure out *what* it is there that appeals to you. Sometimes it is the color scheme, sometimes the cutting or composition. Inspired by that, adapt and relate it to your own work of art. There must be unity and harmony of style, size, shape, and color.

Most importantly, I want to encourage you to remember that everyone has some creative ability. Some take longer to break through the inhibitions. A positive approach is helpful in developing self-confidence. If you're in a dilemma about your choices for a project, try checking this list to identify your problem: is it the pattern, texture, scale, form, space, or rhythm? One of these might yield the solution to your difficulty.

PREPARATION FOR CUTTING

Before sealing and cutting, the following print preparation may be necessary.

"Ladders" are the temporary bridges that keep delicate details in place during cutting and composing. Any fine line that is attached to the print at just one point needs this extra support to keep it from breaking off. Pencil in two parallel lines connecting the tip of a leaf (for example) to the nearest section of the print. Keep all ladders intact while cutting out the print, and cut them off just before gluing down.

Ladders for temporary support.

Thickening narrow lines.

Color over and thicken very narrow lines, extending the color past both sides. Fill in very tiny background spaces with a pencil or the background paint, using a fine brush. For protection, seal all prints after coloring and before cutting.

Two thin coats of acrylic sealer will strengthen and protect the paper for cutting and gluing.

CUTTING: "PAINTING WITH SCISSORS"

Remember the old joke, "How do you get to Carnegie Hall?" and the answer, "Practice, practice, practice!" Once you've learned these techniques, skillful cutting is a matter of practice, practice, practice.

For right-handed people, hold the scissors in the right hand with the thumb and middle (third) finger, the blade supported by and resting on the index finger. The curved blade points to the right, facing away from the paper which is held in the left hand. This feels strange at first, but you'll soon appreciate the value of a clear view of the line you're cutting. The left hand holds the paper loosely and, with a flexible wrist, feeds the paper, turning it full-circle, into the scissors. The right hand remains in the same position, opening and closing the scissors in a steady rhythm, using the full length of the blades. Turn the right palm a little more face up; tilting the scissors a bit bevels the edges of the paper, so it will glue down flatter. Left-handed découpeurs should try reversing this technique.

Holding the scissors.

Ready to start cutting.

Let your arms hang loosely from the shoulder and *relax*. Don't hold the scissors too tight or you'll get sore fingers. You will need good light to see, and a plain cloth or towel on your lap to catch the cuttings. Let me repeat, *relax*, and you'll cut better and enjoy it more. Practice cutting out magazine pictures of flowers, fruits, and animals, so you'll be more comfortable when you start with your prints. Some people prefer cutting with a sharp-pointed knife, but they'll need scissors to do fine serrations. A craft knife is handy to cut out very small interior areas where the scissor movement is restricted.

Cutting away the background and making openings give this print depth and movement.

A large print should first be cut into smaller sections (dotted lines) before the final detailed cutting (thickened lines). The ladders are retained until the whole composition is ready for gluing.

It's easier to hold and turn small pieces of paper, so start by cutting away the background from the design you want to use. A large print should be cut apart into smaller sections at connecting points. If necessary, they can be glued together later. A vertical print can be cut apart and recomposed to fit a horizontal surface. Keep overlapping objects together in groups as much as possible.

First work on the interior and cut out all inner details of the print before you cut out the exterior. Cut from underneath, placing the hand holding the scissors under the paper. Puncture the unprinted area, then bring the scissor tips up through the hole, snip away excess paper, and cut out details.

Cutting out inner details.

Creative cutting employs a variety of techniques to improve and change shapes, and to give depth and texture to a flat piece of paper. "A curve is the line of beauty," so round out those curves in a slight exaggeration. Avoid straight lines; "there are no straight lines in nature," Manet advised. Practice "serrated" cutting by turning and wiggling the paper back and forth as you cut. Try larger, then smaller zigzagging movements, first like those on a butterfly's scalloped wing and then like the sharper edge of a rose leaf.

"Feathering" is cutting to resemble a bird's feathers or a tuft of grass. Cut in sharp, crisp detail, making curved, tapered shapes of unequal length and width.

Cut away some of the interior of a large, solid section. Open up a bunch of flowers to let some background show through. Cut away a leaf, a bud, or stems, or cut down the size of a flower to make openings.

Serrated cutting.

Feathering.

Interior cutting. *Reverse cutting at straight edge.*

Various techniques of creative cutting to produce new shapes and eliminate straight edges.

Create new shapes; get rid of unwanted branches or stray wisps. If there are too many stems, cut some off; vary their length and angle the cuts. Cut off the outside petals of a flower to make it smaller; cut one wing off a butterfly to make the other resemble folded wings as it rests on a flower.

When the print stops in a straight line at the paper's edge, leaving only part of a print, eliminate that line by creating new shapes and cutting away others. Where one object overlaps another, creating two planes, cut sharply and crisply where they intersect. Exaggerating the line where the two planes meet increases the illusion of depth.

Pieces to be composed as a group should not overlap, but be cut to fit like a jigsaw puzzle.

A flat piece of paper will glue around curves more easily if you cut out openings and releases. Make deep cuts around the print edges and reshape if necessary until the paper lies flat when you place it on the curve.

Place your cutouts face up on a piece of black paper. If you see any edges of background paper around your cutouts, then you know you must cut closer to the very edge of the print. Meanwhile, these telltale edges can be eliminated with either coloring pencils or background paint.

Place the cutouts *face down* and study their shapes. Does the silhouette identify and define the object? If not, try improving it with your scissors, cutting off a little at a time, until the abstract shape becomes more specific.

Openings and releases (cut at the thickened lines) enable the print to be glued flat on a curved surface.

With practice, cutting becomes a fascinating, relaxing pastime you can enjoy anywhere, anytime. A pair of scissors and some prints are easily portable and wonderful companions.

An inventive and satisfying composition made up of disparate elements.

COMPOSITION

Composition is defined by Matisse as "the art of arranging in a decorative manner the diverse elements at the artist's command to express his feelings."

Assemble your prints (the subject) together with the object they will decorate, and simply observe them a while. As you arrange and rearrange them, other possibilities will occur to you. Try any combination you can think of. Inventiveness develops an eye for color, patterns, and organization, allowing you to express your own individuality and taste. The more you create, the more aware, selective, and discriminating you'll become. In *The Thinking Eye*, Paul Klee wrote, "Unity . . . is bringing disparate things together harmoniously . . . here the links are important." Think of musical composition, with its rhythm and flow, with all the variations on a theme. A whole note can be compared to a whole bright-red flower; nearby, a half note represents a small paler-red bud; then, perhaps, a quarter note is just a fallen darker-red petal. The intensity of each color, the shading from light to dark, is important to the color scheme. A particular color should be repeated elsewhere in the composition in either lighter (you can erase) or darker shades (you can add color over). The subtle medleys of size and shape and color will hold the interest and please the viewer.

Depth or perspective is achieved by making a color paler or grayer and cutting some shapes smaller than others, to make them recede. Strong, bright colors come forward; paler and darker shades recede.

There is no duplication in nature; no two flowers, plants, seashells, or trees are identical. Each fingerprint differs in every single human being. While selecting and cutting your prints, try for many variations on your major themes.

Start your composition with the largest cutouts or the central motif. First attach them to the surface with the puttylike temporary adhesive and then fill in with the smaller pieces. The placement of the positive shapes creates the equally important "negative spaces." Visualize a piece of lace, or a paper doily, where the holes, the negative spaces, form the overall design. Diversify these as you compose with interesting, irregular, and unequal shapes. Back off from your composition and *squint* at it to analyze the negative spaces.

If you're unsure of the placement, hold a cutout with tweezers, and move it around in all directions until your eye tells you when it's "right." Too much symmetry can be static; use uneven groupings of three, five, or seven. You can achieve balance with subtle changes of similar, but not identical, colors and shapes.

Getting the composition right.

To catch and hold the eye, try to develop subtle tension based on the letter X. Aha! caught you with these unequal lines! The painter Hans Hofmann called this "push-pull"; diagonals pull your eye into the composition, but they don't have to cross or meet. Don't compose in straight lines; set up tension with broken lines— they're eye-catching. Try drawing a 3-in. (7.5 cm.) straight line; now break the monotony of that line into three unequal lengths with unequal spaces between.

Horizontal lines A and B are equal. The perspective created by C and D gives the illusion of A being shorter.

Vertical lines A and B are equal. B's length looks diminished by reversing the position of C to D.

There are many optical illusions, tricks that "fool the eye," which must be seen, rather than described, to be understood; so study these illustrations.

The source of light is almost always from above. The lights and darks on each print direct the angle of its placement. When composing, place areas in shadow at the bottom or side, lighter areas at the top. It is very important, when designing, to see the object at the correct eye level. Put a wastebasket on the floor and see how the composition holds up. Hang a frame or mirror on the wall and look at it from a distance. You've been working close to it; now it is necessary to back off, to *see* it in the proper perspective. Place a three-dimensional object on a turntable and slowly rotate it, checking the rhythm and flow of line and color, called "eye track." The design should lead the eye into and around the object. Chances are you'll need to make some minor adjustments.

If any hardware, such as clasps or hinges, is to be used on your project, mark the size and placement with a piece of drafting tape and leave it there while composing and gluing.

Sign your work. The signature can form part of a composition or be placed in a corner or unobtrusively out of sight. You can also sign on a leaf, for instance, or on part of a print. Sometimes I cut out a little cartouche to surround my name and the date. Use India ink, gold carbon, or acrylic paint.

If you're having difficulty with the composition, take a break and come back to it later. Meanwhile, re-read this chapter! Knowing *when to stop* is also important. When you feel you've done your best, then you can happily start gluing.

COLOR-RELATIONSHIP AND HARMONY

Color, too, can fool the eye. Spread out your prints against various shades of different colors. Get a packet of assorted colored papers and see how the colors in the print change according to that of the background. Some backgrounds will enhance the print, some will subtly mute the print colors, and others might even seem to transform them.

Josef Albers, in *Interaction of Color*, explains it best: "Seeing what happens between colors . . . we almost never see a single color unconnected and unrelated to other colors." Looking at your prints against different backgrounds will develop your eye for color: "practice before theory." The style or period of the prints and the object will influence your color choice; there must be a harmonious relationship between style and color. If your découpage is for a particular room, consider not only the color scheme but also its place in the room. A white frame would blend into a white wall, but a white box would be noticed on a mahogany table.

Any accent color in a print, or lighter or darker shade of that color, works very well as a background. Do not use the same shade of a dominant print color or the cutouts will disappear into the background. A bright-red apple is drowned out by a bright-red background, but if that apple has a bit of yellow or pale green for *accent*, then nature is giving you the color scheme. Choosing color can be an exciting challenge, which becomes easier as you gain experience.

Color Exercise

Create a color wheel on a large piece of unlined paper to make nature's rainbow in a circle. You'll need yellow, red, and blue, the pure primary colors from which all other colors are made. Add white to make a tint, and black to make a shade. Plastic spoons will do nicely for mixing colors on plastic lids. Fill in the red, yellow, and blue spaces and then mix and fill in the secondary colors in between. Use equal amounts of the two primaries to make the secondary color:

<div align="center">

red + yellow = orange

yellow + blue = green

blue + red = purple.

</div>

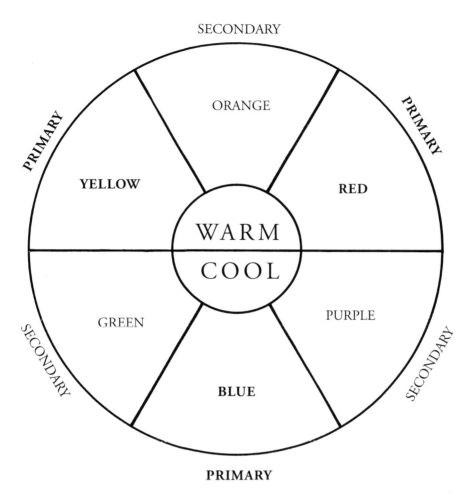

The color wheel. Equal amounts of two primaries make a secondary colour.

Scale of color value or intensity. A tint is made by adding white, a shade by adding black or the complementary color.

Add more of one primary than the other and the color of the one with the larger amount will dominate; thus, more yellow than blue = a yellow green, whereas more blue than yellow = a blue green. Make three columns down the page for tints, shades, and blends of complementary colors. Add a bit of white to each color to make a tint. Example: red + white = pink. In the next column, adding a bit of black to each color makes a shade of darker value. In the last column, add a very small amount of the complementary color to gray it, dulling the intensity.

Complementary colors are opposite each other on the color wheel. Complementaries are: red and green, blue and orange, yellow and purple. A mixture of equal amounts produces a brownish gray. In all cases, the color varies with the amount added. As a general rule, when mixing paint, add the darker color, little by little, to the lighter color.

When mixing a color, wait for the sample to dry to check it; some paints dry lighter and some darker. If you plan to use solvent-based varnish, place a piece of varnished glass over the sample color, then check the color and adjust it if necessary.

Color schemes fall into three basic categories:

Monochromatic Many shades of a single color. Avoid monotony by diversifying texture and pattern; for example, combine silver leaf with a pearl-gray background.

Complementary Muted versions of one or both complementary colors, such as a moss-green stripe on a pale-pink box. Proportion is the key; accent with a smaller quantity of the complementary accent color.

Analogous Colors that are next to each other on the color wheel harmonize. We see it in nature everywhere, in the colors of autumn leaves or the shades of green trees against the blues in the sky.

One side of the color wheel is warm with red, orange, and yellow. The other side is cool with green, blue, and purple. If the prints are predominantly warm colors, try a cool color for the background, and vice versa. Ivory is always safe; neutrals will fit into any color scheme. Or be bold and try a dark background, even black, like a Flemish flower painting. Some prints are improved by a strong, dark background, especially bright, colorful prints.

When planning your color scheme, try another color or shade as a band or stripe, or use it on the inside of a box or on the top of a table.

Each of us has favorite colors. My advice is to use them and enjoy them, not to be afraid of them. How hateful to imagine a world in black-and-white without any color in it!

"Then you will find . . . that you will eventually acquire a style individual to yourself, and it cannot help being good; because your hand and your mind, being always accustomed to gather flowers, would ill know how to pluck thorns," wrote Cennino Cennini in *The Craftsman's Handbook* six centuries ago.

BASIC TECHNIQUES: THE CRAFT SKILLS

"You, therefore, who . . . are about to enter the profession, begin by decking yourselves with this attire: Enthusiasm, Reverence, Obedience, and Constancy. And begin to submit yourself to the direction of a master for instruction. . . ." Cennino Cennini, *The Craftsman's Handbook*.

The basic techniques are "learned skills" that require practice and patience. First and foremost, *relax*: there are no fatalities involved; the worst that could happen can be sanded away, repainted, or, if a print is damaged, replaced.

For now, concentrate on the basic techniques, step by step, with the basic materials. Since the chemistry differs in different materials, please read carefully all labels and instructions.

PREPARING THE SURFACE

Proper preparation is essential; all surfaces must be thoroughly cleaned, dust- and grease-free, to ensure a good bond for paint. The surface must be sanded smooth; imperfections show through the paint and are magnified under varnish.

OLD SURFACES

The amount of preparation required depends on the condition of the piece. Rust and lumpy or flaking paint must all be sanded off. Old paint or varnish can be removed with chemical strippers, paint remover, or paint scrapers before the final sanding. Old painted wood, metal, or ceramic surfaces in good condition should be washed with soap and water, rinsed, then thoroughly dried. A final wiping with mineral spirits removes any grease or wax; then the surface should be sealed. Some woodworkers prefer commercial primers or undercoats instead of sealers, especially on old surfaces. A glossy surface must be sanded down until it is completely dull to bond with the next coat.

The wear and tear on old wood can be part of an antique's charm. However, if you wish to restore the piece, you can repair deep chips or nicks with wood filler.

Press this firmly in place until the area is completely filled in, and sand smooth when dry. Surface repairs can be smoothed over with vinyl spackle. For extensive repairs, refer to *The Furniture Doctor* by George Grotz, the recommended guide to furniture care, repair, and refinishing.

NEW SURFACES

New raw wood should be hand-sanded with medium to fine garnet sandpaper. Cut sheets of sandpaper in quarters, wrap the piece around the sanding block, holding it in place with a rubber band. Sand back and forth *with* the grain of the wood, using an even pressure and steady rhythm. Discard sandpaper when it is loaded with residue. Sand smaller areas with a piece of sandpaper wrapped around a small flat

Wrap sandpaper round the sanding block and hold in place with a rubber band.

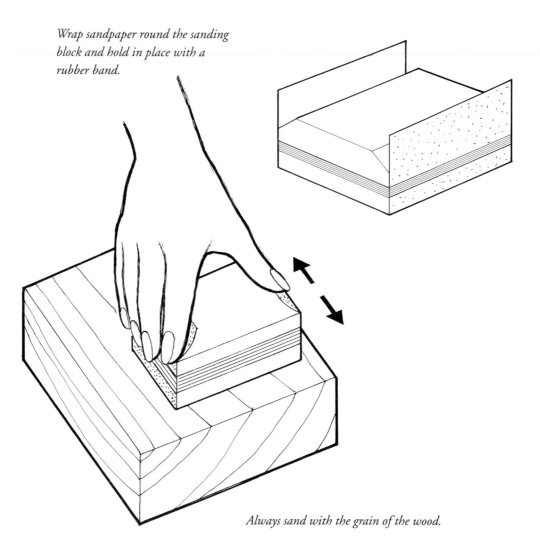

Always sand with the grain of the wood.

To sand small areas, an eraser can take the place of the sanding block.

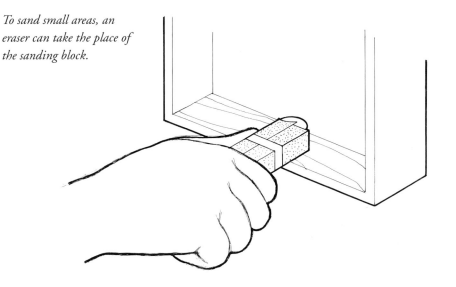

eraser. An emery board will reach tiny spaces. Sand sharp corners and edges ever so slightly, but do not round them. Wipe the surface hard with a tack cloth to remove all dust and grit. Then rub an old stocking over the entire surface; sand the area more where the stocking catches.

Dents in new wood can sometimes be raised by placing a piece of wet paper towel on top of the dent for half an hour.

WOOD BOXES

Use a heated knife or chisel to remove any dried glue inside the box. To remind yourself of the lid's original position, mark the front of the inside of the lid and corresponding place inside the bottom. For boxes with set-in or fitted lids, sand the edges of the wood until it fits loosely. This allows space for the build-up of paint and varnish.

TINWARE (TOLE)

Clean the surface as described above. Rust must be completely sanded off, then wipe with denatured alcohol.

Removing dried glue with a chisel

87

Wash galvanized metal in a solution of half vinegar and half soapy water, rinse, and dry. Dry a few minutes in a very low oven to eliminate moisture. For the undercoat, choose a commercial metal primer one shade lighter than your final paint color.

SEALERS

Sealers facilitate the essential bonding process; ergo the basic rule, "When in doubt, be safe and seal." All porous materials such as wood, marble, leather, ceramics, and greenware (unfired pottery) must be well sealed before painting or gluing.

Wood is porous; it expands and contracts relative to moisture in the air. To prevent warping, seal or prime *both* sides of the wood, especially thin wood which warps easily. If the sealer does not dry smooth, lightly sand with fine sandpaper or rub with 0000 steel wool, and wipe with a tack cloth.

To eliminate wood grain and achieve the smoothest surface, use any of the following:

Quick-dry sanding sealer Fills in the wood grain and is easy to sand. Apply two light coats in opposite directions, with a light sanding after each coat.

Gesso Also fills in the grain and leaves an extremely smooth surface, but is very hard to sand. Apply at least two coats in opposite directions, as smoothly as possible, then sand. One final top coat of gesso, instead of paint, makes a flat chalky-white background; or for a pastel background, tint with acrylic paint.

Shellac Brush on a thin coat of diluted shellac with the grain. One coat is generally sufficient. Spray shellac sealer is recommended for refinishing old wood furniture.

Do not seal wood if you are staining, but sand it smooth; if wood filler is necessary, choose one that matches the wood and will take the stain.

The rule is: seal *before* painting; seal *after* both staining and painting. This protects your background from damage or dirt while composing and gluing down prints.

PAINT AND VARNISH

Follow directions for drying and recoating times on the label. The humidity in the atmosphere, the temperature, and the light all affect drying; usually the label

gives the minimum time. Thin coats are better than thick to ensure that each coat hardens and the moisture evaporates. As you build up successive coats, allow even more drying time to avoid peeling, cracking, or alligatoring. A word of warning: do *not* try to speed up drying with a hair dryer or heater; cracks might develop later on. Try and keep the room at an even, warm temperature; a fan circulating warm air through the room will speed drying time.

The hardening (curing) of paint and varnish cannot be rushed. For example, hours after your nail polish is dry to the touch, it can be dented or damaged because it has not cured hard. So handle your piece gently, and do not set anything on top of it that could leave a mark, especially on oil-based varnish.

TECHNIQUE FOR PAINTING AND VARNISHING

Techniques used for painting are the same as those for varnishing. If required, stir gently to disperse any pigment or fillers that have settled on the bottom; shaking can cause bubbles. Remove surface dust with a tack cloth. Dampen a clean brush (or polybrush) in the appropriate solvent to ease the flow of the liquid. Squeeze out *all* excess moisture until the brush is barely damp. Basic rule: keep the necessary solvent handy to clean your brush or in case of accident. Use different brushes for paint and for varnish, and be sure to label them accordingly. Brushes should be used for one solvent exclusively.

Brush all coats in the direction of the wood grain; changing direction will result in cross-hatching lines. When coating small areas, select a small

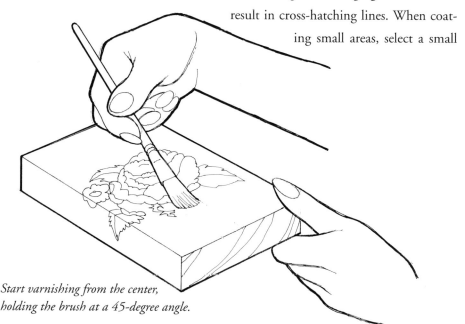

Start varnishing from the center, holding the brush at a 45-degree angle.

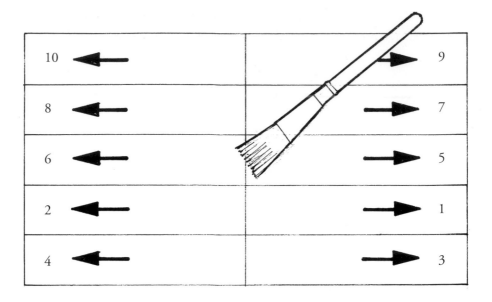

Sequence and direction of stroke for painting and varnishing.

brush; larger surfaces require a larger brush, more heavily loaded with paint or varnish. Dip the brush half-way in the liquid (*never* completely immerse the bristles); let excess liquid drip off. *Do not* drag the brush over the lip of the can or jar; this causes dried particles to fall into the liquid, which will then have to be strained. Hold the brush at a 45-degree angle and apply just enough pressure to maintain uniform contact; pressing too hard causes bubbles. Start with the loaded brush in the center of the surface, stroke to one outer edge, lift the brush, return to the center, and stroke to the other outer edge. Start each stroke of a loaded brush on a dry surface and gradually work back into a previously coated area. Brush with slightly overlapping parallel strokes, so that each stroke spreads the liquid evenly, picking up any excess at the edge of the previous stroke. Lighten the pressure slightly at the outer edges to prevent drips and roll-overs. Wipe off drips with a brush or finger at once. If drips have hardened, carefully slice them off with a razor or knife and let the gummy residue dry before sanding smooth. Many drips indicate that the brush is overloaded.

When coating a box, do the sides first. Place your hand inside the box, turning each side up in order to work on a flat, horizontal surface. Then coat top or bottom; doing the top first will create a ridge around the edges. Be sure to paint and varnish the interior of the box and the lip edges. Use a tiny brush or damp cotton bud to reach the hard-to-get-at inner corners. Prop the coated pieces on tall jars or cans

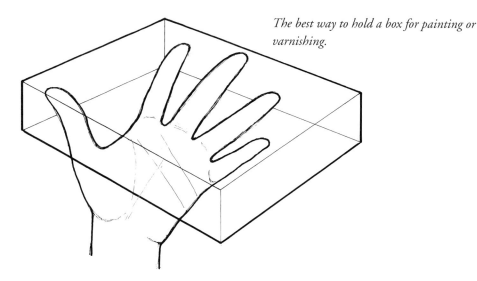

The best way to hold a box for painting or varnishing.

Boxes propped up to dry inside a ventilated carton.

to air-dry. Invert a clean cardboard carton over the piece to prevent dust settling. Remember to cut a few holes in the sides of the carton to allow air to circulate. Practice these techniques for painting and varnishing until they become automatic.

Lift the cutout with tweezers or fingers, place onto the chalk pattern, and pat down gently with a slightly damp sponge from which all excess moisture has been removed. Place a barely damp cloth over the design to absorb excess glue as you roll the brayer over it. (Glue groups of several adjacent small pieces in place before using the brayer.) Using a medium pressure, start the brayer at the center and roll toward the outside edges in all four directions. Remove the cloth and examine the paper for bubbles or wrinkles. Pop air bubbles with a pin and then press the paper flat with your

Use the brayer over a damp cloth to roll out excess glue and air bubbles.

fingertips. Roll your fingertips back and forth over a wrinkle to smooth it out. To glue a cutout over a sharp edge or around a sharp corner, first crease the paper where it will fold, so that it can be glued flat to both surfaces. Clean off excess glue with a damp cloth or sponge. Wipe from the center of the print past the edges in order to flatten, not lift, the edges. Clean off small interior openings with a damp cotton bud.

Clean off glue with a damp sponge. (Cutouts should first be creased before gluing round a sharp corner.)

Should you change your mind and wish to remove a glued print, soften the glue by dampening the edges with hot water on a cotton bud. Gently lift the edge with a knife, and continue dampening and lifting while rolling off the print. Let the paper dry before regluing.

When the glue has dried for 5 hours, take the burnisher and press down firmly on the print's edges to flatten and embed them. Pressing too

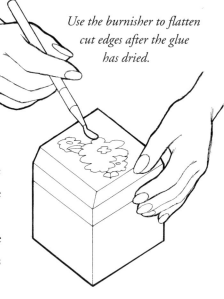

Use the burnisher to flatten cut edges after the glue has dried.

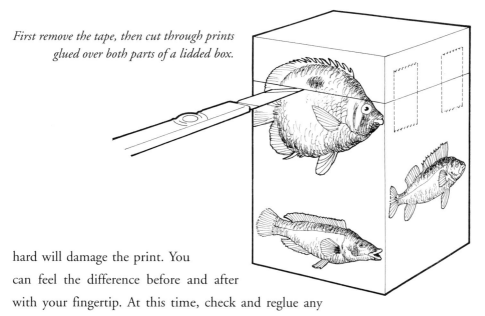

First remove the tape, then cut through prints glued over both parts of a lidded box.

hard will damage the print. You can feel the difference before and after with your fingertip. At this time, check and reglue any edges that might have lifted. Push more glue in with the tip of a brush or a toothpick and hold the print down firmly for a moment. Remove any shiny spots of dried glue with a cotton bud dampened in hot water.

To glue a cutout across the two pieces of a lidded box, tape them together tightly before gluing the design in place. When the glue is dry, remove the tape and, keeping the blade straight, cut through the opening with a craft knife or razor blade. Reglue if necessary, and color the white edges of the cut paper. Allow the glue to dry 6–8 hours before varnishing.

For large whole prints (not cut out), delicate intricate cuttings, or thin paper, spread matte medium directly on the surface instead of on the paper. The medium won't grab as quickly, allowing more time for positioning. This eliminates the problem of the paper curling up and around when spread with wet glue.

Also when working with whole (uncut) prints, first coat both front and back with matte medium, allowing each coat to dry clear—about 20 minutes. "Wet mounting" will eliminate wrinkles. For this, sandwich the coated print between wet paper towels for 10 minutes while the moisture stretches the paper. Coat the surface with matte medium, then position the print at the bottom and slowly roll it toward the top. Rolling pushes out the air and helps eliminate air bubbles. Place a damp cloth over the print and roll out excess medium with the brayer. The paper will shrink as it dries. When completely dry, coat the entire surface with one or two coats of matte medium before applying any other clear finish coat.

FRAMING

To miter the corners of borders or decorative trim, cut each strip 2 in. (5 cm.) longer than the side it is to fit. Glue the strips in place, leaving edges and 1-in. (2.5 cm.) overlap unglued at each end. With straight scissors, cut through both pieces at the corner diagonally, from inside corner to outside corner. Lift each end and glue in place for a perfect fit.

FINISHING AND POLISHING

FINISHES

It is essential to protect your work with layers of transparent finish. Its mellow glow and rich depth complement the découpage. Use the same procedure as detailed earlier under "Technique for Painting and Varnishing." Check the label regarding the type of brush to use, whether stirring is required, drying time before recoating, and curing time to polish. Moisture in the air will cause bubbles in the varnish. If the varnish wrinkles or puckers, you must allow more drying time. When it is thoroughly dry, lightly sand and tack. The next coat of varnish will build up and fill in. Buy enough for your project and *please* don't mix brands; they might not be chemically compatible and could peel off later.

Some guidelines that will influence your choice of finish:

Background color For white and pastels, use an acrylic finish to avoid yellowing. For a better patina, after wet-sanding the acrylic finish (see below), apply one or two coats of varnish; there will be no visible color change. (Run a test with your own products first.) For dark colors and gilded pieces, solvent-based varnish enhances the surface best.

Durability For wastebaskets, trays, table tops, etc., the "hard acrylic" finish is stronger and less likely to chip. Polyurethane is sturdy and appropriate for objects that get hard use.

Sheen Most finishes come in a selection of sheens from high- to low-gloss. Select a suitable sheen for the style of the découpage piece. A low-luster finish can be accomplished two ways: (1) wet-sand and polish any type of finish, and (2) for durability, first build up coats of high-gloss or semi-gloss, then after wet-sanding, apply a few coats of low-gloss.

It takes a lot of practice to apply finish coats skillfully. Do not be discouraged; the wet-sanding and polishing will magically transform your work. Successful finishing requires a clean object (tack it) and a clean brush (dampened in solvent). Thin coats are best; they dry faster and cure harder. Whenever possible, start a loaded brush on the painted background, not on top of a cutout; this fills in and builds up the background level with the paper. When the brush skips over tiny spaces between cuttings, fill them in with a drop of varnish on the corner of your brush. Successive layers may take longer to dry. Test at a corner by pressing your thumb down; if it leaves a print, wait to recoat. Remember: prop up pieces to dry on jars and keep clean with a dust-cover carton. Clean the brush in solvent.

One of the most frequently asked questions is "How many coats of finish are necessary?" This is a matter of personal choice between seeing the print contour slightly raised or seeing the surface flat, which requires more coats of varnish. In practical terms, a piece that is going to get a lot of wear and tear needs more protection than one that is purely decorative. No two people apply the exact same amount of finish in each successive coat; so my rule of thumb is, when you are pleased with the "look" of your finish, add three more coats to compensate for the shrinkage during the curing process. Usually an average of 8 to 10 coats of finish are required before you can wet-sand.

WET-SANDING

Before starting this process, check that the edges of the cutouts slope down to make a beveled edge. If the edges are sharp when you run a finger across the surface, be on the safe side and add more coverage.

Wet-sanding removes any brushmarks, dust, or bubbles and polishes the surface to a professional finish. There is no substitute for the elbow grease required, but I promise you that the results are well worth the effort. The prints are enhanced by the depth of the finish; it's a kind of magical transformation.

Supplies

dish of sudsy water	0000 steel wool
dish of clear water	small flat sponge
400 wet-and-dry	paper towels
sandpaper	soft cloth

Wet-sanding with plenty of soap-suds.

The finish must cure before wet-sanding. Wait several days for solvent-based varnish to harden and one day for water-based finish. Wrap a piece of sandpaper around a flat sponge (don't use a hard sanding block) and saturate it with the very sudsy water—yes, soaking wet! Start at the bottom or back, and sand back and forth in the direction of the grain, using a light pressure. Work very lightly over the prints and sharp corners. Sand the whole piece smooth, working gently in order not to remove all the varnish. When it feels smooth, clean off all the soap with wet paper towels and dry with a soft cloth. If you sand through the varnish, stop at once, dry off, and repair the damage with oil pencils or matching paint. If the water-based finish has cloudy moisture patches, they will quite quickly dry clear and you can continue. Just feel the smoothness, even though it looks very dull at this stage. If there are shiny areas around the edges of the cutouts, remove the shine by rubbing lightly with 0000 steel wool (dry, never wet). Clean away steel wool particles with a tack cloth.

If you choose to add more finish, you can start recoating in an hour; however, always end with a final wet-sanding. The perfectionist can continue on with either 500 or 600 wet-and-dry sandpaper. Otherwise, the next step is to hand-rub the entire surface with 0000 steel wool; go back and forth, pressing a little harder now. Clean off and rub an old stocking or pantyhose over the surface with medium pressure, polishing it to a soft glow.

FINAL SHEEN

You have the following options for the finished look:

Matte finish For a low-luster, satin look, simply wax and buff. Use a white or colorless, good-quality furniture paste wax; apply sparingly with a damp cloth, wait 10 minutes, and buff with a soft, dry cloth.

Semi-gloss finish Polish with a liquid mixture of rottenstone or pumice and colorless oil (mineral, lemon, or baby oil). Rub on the mix with a felt pad or old soft cloth, back and forth, using a medium pressure, until you achieve the desired sheen. Remove all traces of the oil with a clean, dry cloth. A well-buffed coat of wax completes the task.

High-gloss finish This very high sheen requires one or two final coats of thinned-out gloss varnish applied *very* carefully. Dilute 7 parts varnish with 2 parts mineral spirits; coat quickly and evenly; then prop up to dry, protected from dust with a carton cover. Some automotive polishing compounds will produce a very high gloss, eliminating the need for waxing.

Now you can appreciate the result of all your efforts, the sum of all the parts, glowing magnificently—not only a delight to the eye, but also to the touch. Watch how everyone responds—picking the piece up, feeling it, examining it—and you can be very proud of yourself and your work.

HARDWARE AND LININGS

HARDWARE

Install hinges, feet, or clasps right after polishing, before the finish completely hardens. To install hinges on a box, first check the length of the screw against the thickness of the wood. Clip off the ends if they are too long, or else find shorter screws. Tape the box together, then tape the hinges in place, measuring equal spaces from both edges. A center-finding ruler does the measuring for you. Start the holes through the tape with an awl or ice-pick and remove the tape when the screws are half-way in. Rolling the screws into a bar of soap helps them to penetrate the wood. It may be necessary to tighten the screws later on as the varnish shrinks.

First tape the hinge in position, then start the screw-holes with an awl.

Make sure the screws are not too long.

LININGS

A paper or fabric lining is a nice surprise inside a box where there is no découpage. Coordinate the lining to the style of the piece. Wallpaper, marble paper, tea paper, doll house paper, rice paper, gold or silver leaf, velvet or silk, all can be used for linings. Self-adhesive papers and felt are easy to use and don't require a backing.

Fabric is best for a jewelry box; a quilted fabric makes a nice cushion on the bottom with a bit of potpourri inside. For practical use, spray the fabric with two coats of acrylic sealer (first tested on a scrap), unless it is already treated. Lining can be glued directly to the box, but it's preferable to attach it first to a backing before gluing to the interior. Use thin cardboard (thick is too bulky) or a manila file folder for the backing. Measure the inside of the box from one corner around two sides to the opposite corner, then measure the depth and make both side patterns. Cut the cardboard backing an extra ½ in. (13 mm.) wider where the side seams will overlap at the corners. Crease the corners sharply, scoring the cardboard with a ruler. Place both side pieces of backing in the box, then measure separate pieces for the top and bottom to fit accurately. Place the patterns on the paper or fabric. Cut out the paper or fabric around the patterns, allowing an extra ¼-in. (6 mm.) border all the way round.

Cut diagonally across all four corners of the fabric to miter, so the lining will lie flat. Leaving out the ½-in. side seam, glue down the ¼-in. border all around the edges and press it down flat. Coat all the sides of the box with glue, press the lining in place one side at a time, then glue the overlap side seam. Next, glue the bottom in place and press down flat. Protect paper linings with 2 to 3 coats of finish after the glue has thoroughly dried.

Sometimes on complicated shapes it is easier to make a pattern with aluminum foil. Place one long piece of foil inside the box; fit it flush into every corner, going all the way around the inside, and leave a ½-in. (13 mm.) overlap for the seam. Then cut a second piece to fit the bottom.

Try to remember: the real beauty of a handcrafted object is that it is not perfect—human hands, rather than machines, have formed it.

Making a pattern for a lining with aluminum foil.

BASIC OUTLINE FOR DÉCOUPAGE ON WOOD, TIN, OR CERAMICS

SURFACE

1. Prepare background, repair if needed, sand smooth.
2. Seal background (omit if staining).
3. Paint 2 coats, sand, apply final coat of paint; or
 Stain, polish with steel wool when dry.
4. Seal background.

PRINTS

1. Color if desired, draw ladders.
2. Seal front of prints.
3. Cut out prints.
4. Arrange composition with adhesive putty.

GLUING

1. Mark position of cutouts with chalk.
2. Apply glue to back of print and place in position.
3. Roll with brayer and remove excess glue.
4. Bevel print edges with burnisher.

FINISHING

1. Build up approximately 8–10 coats of water-based or solvent-based finish, before:

WET-SANDING

1. Use plenty of soap-suds, sand until smooth.
2. Rinse off soap and dry well.

Optional: add more coats of finish, then wet-sand again.

POLISHING

1. Rub with 0000 steel wool and clean off.
2. Polish with old stocking.
3. For matte: wax and buff.
 For semi-gloss: polish with oil and pumice, wax and buff.
 For high-gloss: apply final coat of gloss varnish (thinned).

OPTIONAL

Install hardware (such as hinges) and lining.

SUGGESTION

Photocopy this outline and hang it over your own work table.

POTICHOMANIA: DÉCOUPAGE UNDER GLASS

It's no wonder découpage under glass is so popular today in this age of instant gratification. There's no wood or varnish to sand and polish—in potichomania, glass replaces varnish with equally gorgeous results.

The technique is the reverse of working on wood. First the cutouts are glued *under* the glass, then the background is applied. Simple projects such as plates, coasters, or switchplates can be completed in a day or two. After a bit of practice, you can advance to more intricate shapes, such as bowls, jars, vases, or lamps.

PREPARATION

Wash the transparent piece of glass by adding ammonia or white vinegar to soapsuds and wipe clean with a damp chamois. Rinse well and dry. Avoid fingerprints by handling the glass with paper towel. Do not use commercial glass cleaners; they contain chemicals that can discolor the prints and resist the glue. Prepare the prints by sealing the *back* before cutting. Also seal the front of handcolored or handpainted prints, to prevent the color from bleeding.

Large prints need to be cut apart into small sections for easier gluing. Where you have areas larger than 2–3 in. (5–7.5 cm.) in diameter without any openings, use a craft knife or razor to make some inconspicuous interior slits along lines in the print. These cuts provide the exits for air bubbles and excess glue; they will not show when pushed together in place.

A large flat piece of paper will not glue flat against a curved surface. It is necessary to make interior cuts, or releases, so the paper won't pull away when glued. Place the cutout on the curve and cut the paper until it lies flat to the glass. If those released edges overlap, it won't be noticed under glass; just be sure both pieces are glued down tight. There's even a way to make thick paper fit flat to a curved surface. Dampen the paper, and place it on the curve (with temporary putty or rubber bands) and let it dry in place. When you remove it, the paper will have dried in a curved shape and will be easy to glue.

COMPOSITION

For a flat object, such as a plate, make a paper pattern (template) by tracing around the edge with a pencil. Arrange the cutouts on the paper, then lower the glass over them. When you are satisfied with the design, outline and number the pieces with a grease pencil on the front of the glass. Number the corresponding cutouts on the back with a pencil.

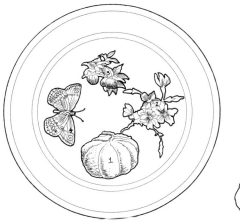

With a flat glass object, place it over the composition, then outline and number the cutouts with a grease pencil on top of the glass.

Mark the backs of the cutouts with the corresponding numbers.

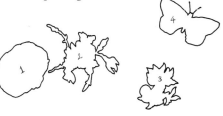

For curved vases or lamp cylinders, arrange the composition on the exterior of the glass, using removable putty. Put a piece of colored tissue inside the glass, so your eye won't be distracted by the other side. Set the glass on a turntable, rotating it slowly to study the composition. Then outline and number the cutouts as before. Wrap plastic wrap around a cylinder to hold the pieces securely. Make extra cuttings for lamps; they take more prints than you might think, and you might want to decorate the shade as well.

With rounded glass items, arrange the composition with removable putty and study it against a background of colored tissue.

GLUING

MATERIALS NEEDED

matte medium (as glue and sealer)

damp synthetic sponge, or ¼ in. (6 mm.)
 foam rubber cut 4 in. (10 cm.) square
 with the four corners held together
 by a rubber band to make a tamp

tweezers

eye dropper

extra-long pin

cotton buds

paper towels

dish of water

plastic wrap or foil

plastic lid

polybrush or soft 1-in. (2.5 cm.) brush

damp disposable honeycomb cloth, or
 clean lint-free cloth

Start with the main pieces, and glue one piece at a time. Pour some matte medium into the plastic lid. With the brush, spread an even layer of medium on the *back* (inside or underside) of the glass, filling in the outlined area. Press the *front* of the print into the medium and lay the damp cloth behind it. Lift up the glass and, looking at the front, check that the print is in its outline. Air bubbles will appear as shiny spots that must be pressed out to the nearest exit with a damp cloth. Press out excess pools of white medium from the center to the nearest edge, but do *not* remove too much or it will leave a shiny area when it dries. Always leave more, rather than less, medium; it may take longer to dry, but it will dry clear. Now clean the excess medium from the glass with a sponge or cloth.

Press out air bubbles with a damp cloth.

 Place the smaller pieces on plastic wrap or foil, coat the front with matte medium, and lift into place with tweezers. Clean up as you work with hot water on a dampened sponge or cotton bud. A damp paper towel will remove the grease

pencil marks. Prop up a plate upside-down to dry. If your project is a cylinder, lay it securely on its side on a large towel (to prevent it rolling off) for several hours to dry, turning occasionally.

Check that all edges are well glued to the glass, so that paint won't seep under the print. Reglue any loose pieces by pushing a long pin between the print and the glass, gently lifting the print; then, with an eye dropper, drop matte medium into that area. Hold the piece so that gravity will allow the medium to fill in the space; then remove the pin and press and hold until the glue (medium) grabs. Any shiny areas will need to be reglued this way.

Wait until the glue under your prints is dry and clear. Pat a *thin* coat of matte medium behind the glass and the back of the prints; this gives a good bond for a painted background on slippery glass. Excess medium creates a texture, so pick up any excess immediately with a slightly damp sponge; this coating will dry nearly transparent in about 20 minutes. Omit this step if the background is to be rice paper or gilded (see below).

Use these same materials and techniques for objects made of clear plastic.

BACKGROUNDS

It's fun to experiment with a variety of backgrounds to set off the découpage: paint, metallic wax, pearl, glass stain, gesso, crackle, rice paper, tea paper, even sand. Acrylic paint or gesso should be *patted* on over the entire back of the glass in a thin, even coat with a foam-sponge tamp. Patting applies the paint better than a brush, which leaves brushstrokes. After painting a flat piece, set it upside-down on top of a jar or can to dry for 12 hours, allowing all the moisture to evaporate. If you apply the second coat too soon, or put it on too thickly, the paint might crack.

When painting a cylinder that is open at both ends, start painting in the center and work your way in a circular pattern toward the opening. Turn it around and paint the other half. Turn and rotate the cylinder as it dries. After 12 hours' drying time, pat on the second *thin* coat of paint, and if necessary a third. Double the drying time if the cylinder has one closed end.

The painted edge of a plate should be crisp and precise, so shave round it with a sharp knife or razor when the paint is dry, but before it has cured. A rim of gold around the edge of a plate can be drawn with a permanent magic marker or painted carefully with a small brush.

GILDING AND SPECIAL EFFECTS

The artist Charles Prendergast poetically described gold leaf as being like "a half-solidified piece of sunlight."

Since early Egyptian times, gilding has been used for decoration and ornamentation. Thin sheets of gold leaf are applied to a well-prepared surface, then polished to a high shine. This refracts light and its brilliance attracts and holds the eye. But all that's gilded isn't necessarily gold; there are silver, aluminum, copper, and marbleized leaf as well. As a background for découpage, "Dutch metal" is the easiest to handle and cheapest to use; this is composition leaf containing copper and brass. The leaf comes in "books" of 25 sheets, 5½ in. (14 cm.) square, each separated by a page of tissue. Tissues on either side of the leaf make a "sandwich" which can be handled without harm to the leaf. Beginners should practice on a flat surface first, to get the feel of it and discover that this "sandwich" technique is really easy (see "The Gilding Technique" below).

EQUIPMENT AND MATERIALS

book of leaf	tweezers
gold size	talcum powder or cornstarch
varnish	1-in (2.5 cm.) soft-hair brush for size
tack cloth	1–2-in. (2.5–5 cm.) soft fluffy brush
cotton (cotton wool) balls	for tamping (optional)
feather	antistatic spray
piece of China silk or silk velvet	0000 steel wool
straight scissors	sandpaper (extra-fine)

GILDING ON WOOD

The proper preparation of the surface is extremely important. Any imperfections will later be magnified by the gold leaf. The wood must be smooth, clean, dust-free, and non-absorbent. (See Chapter 6 for surface preparation.) Quick-dry sanding sealer makes an excellent non-porous base. Gesso, which was traditionally used

under leaf, tends to crack as the wood expands and contracts over time. Two coats of water-based paint are sufficient to give a glow and hue beneath the leaf's semi-translucence. Traditionally, a warm red was used under gold, and dark cool colors under silver leaf. A mustard-yellow paint under gold will camouflage the holes or cracks (faults) in the leaf. Harmonize the background color with your print colors. Sand the paint smooth, seal the surface well, and again sand or rub with 0000 steel wool. Tack very carefully, removing all dust and residue.

SIZING THE PIECE

Size is diluted varnish that fixes the leaf to the surface. To make size: mix 4 oz. (120 ml.) gloss varnish with 2 tbsp. (30 ml.) turpentine and add 2 to 3 drops of Japan drier. If the varnish is thick to begin with, thin it up to 50 percent with turpentine. Both quick-drying and slow-drying size can be purchased ready-mixed.

For small projects use quick-dry size, which becomes tacky and ready to use after about an hour. In a well-lit, warm, dry, draft- and dust-free area, brush on the size in the thinnest possible even coat, leaving no uncoated areas (skips). Squeeze out the brush in paper towel and restroke in the opposite direction, picking up any excess size. Prop up the project to dry; surrounding it with *wet* sheets of newspaper will repel dust. After approximately 45 minutes, test for the proper "tack" by gently placing a knuckle on the size and pulling away. When none comes off on your knuckle, and you feel a pull and hear a clicking sound, the size is ready. Cool temperatures or humidity will extend the drying time. The drier the size, the more lustrous the leaf, so be patient and use the waiting time to get everything else ready.

THE GILDING TECHNIQUE

It is advisable to learn the technique by first working on a practice board.

First dust your fingers with a little powder, away from the table. Now is also the moment to apply the antistatic spray to yourself. With straight scissors cut off the "spine" of the book of leaf, each sheet of which can be handled easily between two sheets of tissue (like a sandwich). Cut a half-dozen sheets (with their tissues) into four quarters and gently smooth the

Cut off spine of the book of leaf.

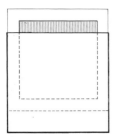

*Partly slide out bottom
tissue of leaf sandwich.*

cut edges down flat. Pick up one leaf sandwich, slide the bottom tissue down 1 in. (2.5 cm.), then lay the exposed length of leaf on the sticky size, slide out the bottom tissue, and gently press the top tissue with soft fingertips until the leaf adheres to the size. Starting from the upper left-hand corner, lay the leaf straight across the surface, then lay the second row, and so on. Try to keep the seams aligned. Every piece must overlap the adjacent piece ¼ in. (6 mm.) in order to have perfectly covered seams. Optional: you can make a pattern by aligning the seams and marking the surface with pencil *before* brushing on the size. When all the surface is gilded, take a *very soft* brush and smooth the overlapping seams, brushing in the direction of the overlap. Brush away any air bubbles and gently press the leaf to adhere to the size.

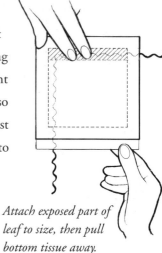

*Attach exposed part of
leaf to size, then pull
bottom tissue away.*

Dry overnight, then burnish the leaf with a ball of soft cotton (cotton wool). With a light pressure, rub away wrinkles and excess leaf. Collect these small pieces (skewings) with a feather and sweep into an envelope. Polish softly with a piece of China silk or silk velvet for greater brilliance.

*Lay down leaf in the sequence shown, keeping the seams aligned.
When dry, burnish with ball of cotton.*

Some find it aesthetically pleasing for hints of paint to peak through the cracks ("holidays") in the leaf, eliminating that "new" look. This antique "broken-leaf" look can be made while you gild by pulling at the leaf after the first inch (2.5 cm.) is attached to the size. Accidental "holidays" can be patched by pressing another piece of leaf over the crack while gilding. If the size seems too dry for the patch to stick, try blowing hot breath directly on the size at close range and quickly press the leaf in place. Patching can also be done later after burnishing by brushing the size over, and a bit beyond, the cracks to be covered. When the size is tacky, patch and then repeat the burnishing process.

Gilding carved pieces, routed edges, or corners is tricky, so use two pieces of leaf in the "sandwich," then tamp firmly in place with a brush. (If the first piece of leaf cracks, the second piece will hold.) This sandwich technique is the easiest way to handle Dutch metal; with a bit of practice, you'll be really pleased with the glowing results.

Gilding combined with paint makes a sophisticated, eye-catching background. Gild only the top of a painted box or table, or decorate with a band of gold leaf. Seal the paint and mark the area to be gilded with a pencil (white charcoal pencil will show up on a dark background). Powder the adjacent surfaces, carefully size the marked area, and proceed as above. If an unruly bit of gold attaches itself elsewhere, remove with turpentine on a cotton bud.

Most Dutch metal must be sealed and varnished to prevent tarnishing. Only aluminum (called "silver") does not tarnish. Applying a few varnish coats over the silver results in a lovely silver-gilt look. More coats of amber varnish make the silver look gold, but with a soft satin sheen. Seal with shellac or varnish, and let dry to protect the leaf before gluing the découpage. Use semi-gloss sheen for a final finish—high-gloss is too garish. Build up varnish and polish.

Recently I completed every technique on a bombé chest (see page 52) with only the newest water-based materials. The sanding sealer, paint, size, antiquing, and varnish, even the treatment of the brass hardware, were all accomplished with non-toxic, fast-drying materials. Distressing the leaf, then antiquing the entire surface (see below) emphasized its curves and softened the newness of the piece. I coated the handpainted silk (from De Gournay) front and back before cutting, and also glued it with matte medium. The new acrylic Quick Size was tacky in 5 minutes, and it will stay so for 24 hours. (I hope it will be widely available soon.) Everything proceeded so quickly and easily. I hope you approve of the results as much as I do.

ANTIQUING

Antiquing ages and mellows paint and dims the brightness of leaf. If antiquing is appropriate to the piece and the prints, practice and perfect these techniques on a sample board. Abrading the leaf imitates the natural wear and tear of aging, so use 0000 steel wool to rub off the leaf from those areas normally worn by handling, especially the edges, corners, and seams; or rub the leaf with newsprint, so that some ink comes off and subtly tones it; or rub it with rottenstone powder to achieve that dusty, aged look.

Alternatively, add your color to a ready-made transparent glazing liquid; then brush the mixture over the varnished surface. Wait a few minutes before carefully wiping some off in even strokes, in one direction, with cheesecloth, crumpled tissue, or paper towels, to expose the ground color. For a *strié* effect, pull through the color-glaze with a coarse-bristle brush or a pad of steel wool. When it's almost dry, subtly blend it with a soft, fluffy brush. This technique can also be used with thinned-out water-based paint, but it dries so quickly you must work very fast in small sections.

Sponging on both thinned-out paint and glazing liquid gives a mottled, stippled appearance. Soften the sponge in water and squeeze out until almost dry before dipping in glaze or paint. Blot the loaded sponge on absorbent paper towel, then lightly dab onto the surface. Try for a varied pattern by rotating both hand and sponge when loading and patting on the glaze. A natural sea-sponge gives random, uneven markings, unlike the even pattern of a cosmetic, synthetic sponge.

Fly-specking, whether spattering with diluted paint or India ink, should be subtle. Dip an old toothbrush into the runny liquid, then tap off the excess on a paper towel. Pull a craft stick across the bristles to spatter, keeping both hands moving over the surface. Soften the spatters by blotting with facial tissue and/or blending with a soft, fluffy brush.

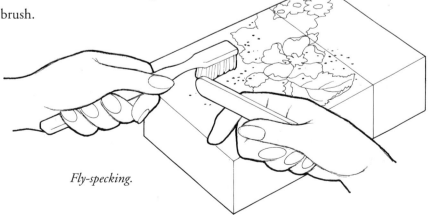

Fly-specking.

Instant antiques are frequently made using crackle medium. Follow instructions on the label—different formulas vary. Using one product on top of another, each with different drying times, results in the cracking. Rub a contrasting color into the cracks to make them more noticeable.

Place your cutouts on the antiqued surface to check the effect. The background should enhance, not dominate, the prints. Should you decide to antique after you have varnished the découpaged piece, wipe off most of the glaze from the face of the prints and let the piece dry thoroughly before adding more varnish. A dull satin finish is the most appropriate over antiquing.

GILDING UNDER GLASS

Start with a simple flat piece of glass, such as a plate. Glue the découpage, and thoroughly clean off the excess glue. Brush on a thin coat of size over the entire back of the piece and the prints. When the size is tacky, lay the leaf on the back of the piece and try to match the seams. (It is not possible to match seams on a curved piece, such as a hurricane shade.) When the sandwich technique won't work, lift the leaf with tweezers, and dab and pat it into place with a soft brush. Push the leaf up to and around the edges of the print with a cotton bud. Repair and patch (with left-over skewings) any breaks at the print's edges. Burnish with soft cotton (cotton wool) when the size is dry. A second coat of leaf over the entire back surface will camouflage imperfections.

Another way to gild inside the glass is to cut the sheet of leaf into quarters. Cut wax paper into pieces ¼ in. (6 mm.) larger than the leaf. Remove the top tissue and press the wax paper onto the leaf. Lift the wax paper (the leaf will remain attached to it), lay it on the sized surface, and pat gently into place; then lift off the wax paper. Seal well, then paint over the leaf, choosing a color compatible with the print. Seal again and varnish to protect the leaf and paint from moisture or damage.

BASIC OUTLINE FOR GILDING

On top of surfaces (wood, tin, etc.)

1. Prepare surface: clean, (if wood) fill grain with sanding sealer or gesso, smooth, and seal.
2. Paint base coat, smooth with 0000 steel wool, and seal.

TROUBLE-SHOOTING

Whether you take the high road or the low road, you *are* going to get there. The end result is what's important. I recommend the surest, swiftest, and safest from my own experience. Take comfort—a wrong step is never fatal and can always be corrected.

For those doubtful moments, better be safe than sorry. When in doubt, take the time and seal the surface. Will the products be compatible? Test on a sample board first. Trying a new technique? Start it at the back or on the bottom.

Camouflage will often improve an unattractive surface. Try crackle or antiquing, a sprinkle of bronzing powder or pearl powder, or a thin layer of rice paper. Of course, there's always the option of sanding and repainting.

REPAIR CLINIC

The finish is cracking Either rub color in the cracks for an antique crackle, or sand down a few coats and add more finish to fill and level.

The print has lifted Make a sharp cut at the edge of the print, force glue underneath, and hold it down until it stays flat. If you wish, add finish.

A chipped corner With a small brush, fill in layer after layer of finish. If the paint has chipped too, cover with matching paint on a cotton bud before applying the finish.

A bad spot Glue another cut-out piece on top of the spot; then apply more finish.

A crack in the glass lamp or jar that's been découpaged Glue more prints to the front of the glass, then protect with finish coats. The three-dimensional look is most attractive—everyone will think you meant it to be that way.

There are tricks to every trade, and we, too, have our fair share.

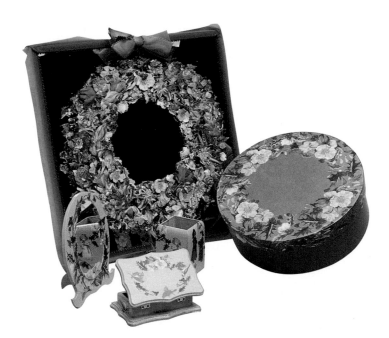

The Christmas rose with holly and ivy print comes in two sizes; both were used, plus others to scale, on this grouping. I use the 12-in. (30 cm.) round box to hold Christmas cards or sometimes cookies. Ombré ribbon frames the three-dimensional wreath découpaged on the mirror.

Traditionally, Victorian cornucopias decorated the Christmas tree (see Chapter 9 for how to make them).

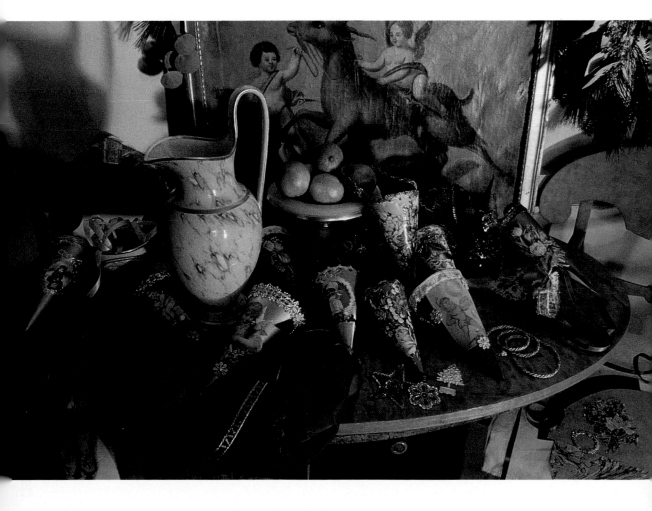

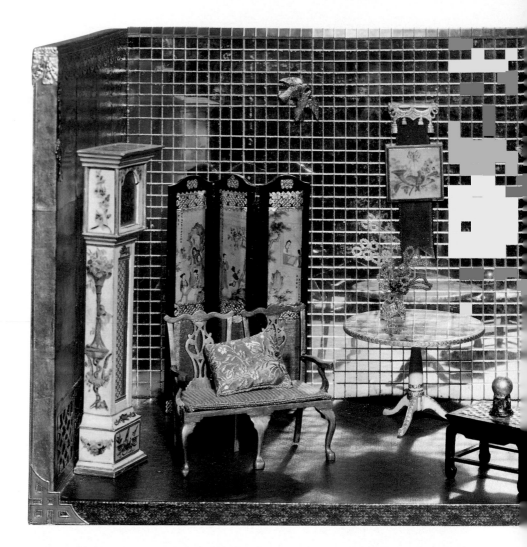

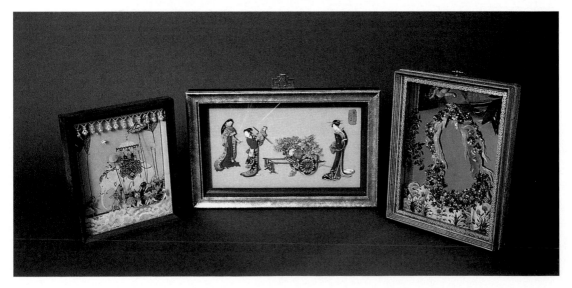

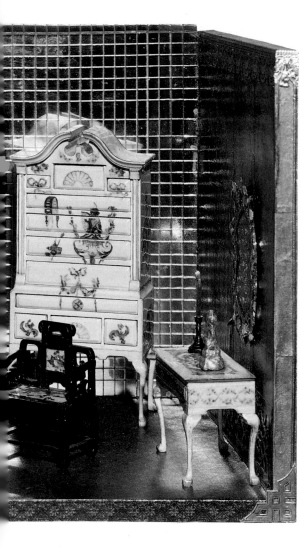

Visions of Cathay were the inspiration for this miniature (1:12 scale) room. The furniture, except for the Mandarin chair and table, was made from commercial kits, painted and gilded, then découpaged. I used much embossed paper trim, gold, silver, painted, and antiqued.

Paper sculpture, or three-dimensional découpage, (opposite, below) has many devoted followers. Noriko Ishikawa trimmed her Indian elephant picture with laces and jewels. Silk shantung is the background for Lois Silberman's Japanese prints framed in antiqued silver leaf. See yourself as Primavera in the mirror—can Botticelli ever forgive me?

A few of Amy's nursery things. Sections of the sheet music for "Once in Love with Amy" decorate the wood-stained box with her birth announcement. Kate Greenaway alphabet letters adorn sides, seat, and back of the chair. I made another turtle for a little boy who insisted on taking it everywhere he went.

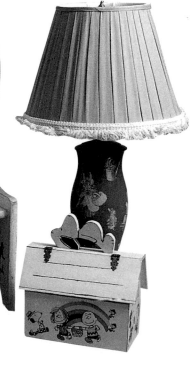

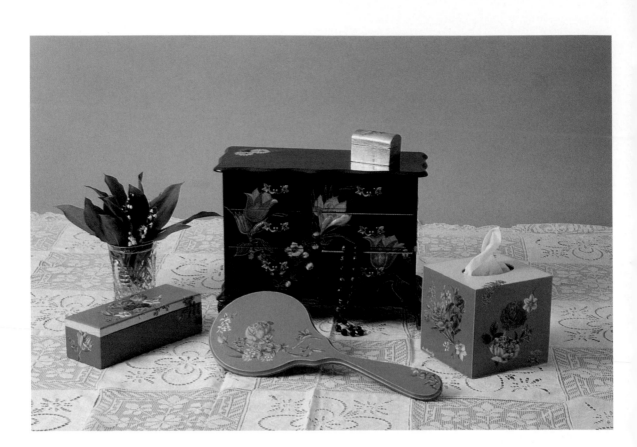

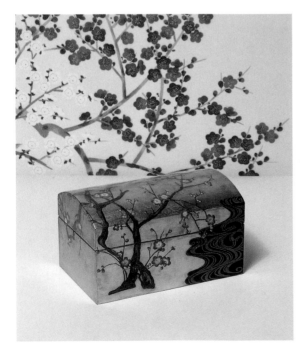

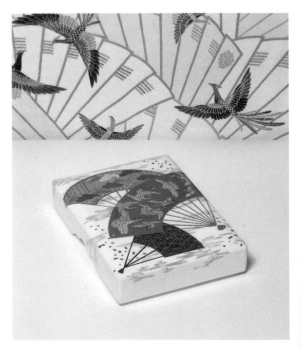

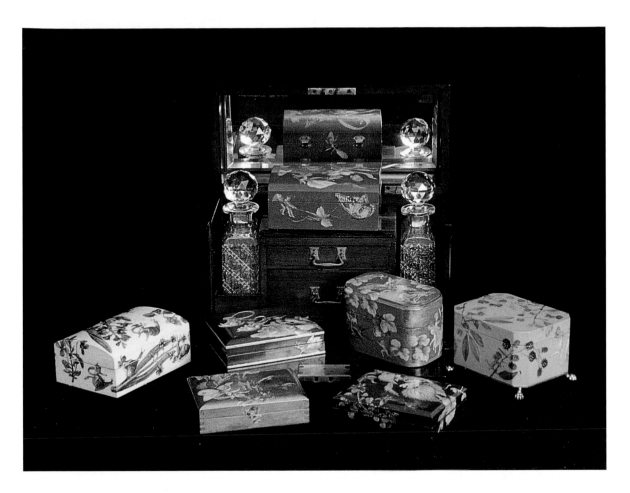

The large pink flowers on the black jewelry chest *(opposite, above)* are done in repoussé. Noriko Ishikawa sculpted them to contrast with the smaller, flat flowers. One small red rose is repousséd on the silver-leaf miniature trunk *(painted dark green inside)*. Two paint colors make a more interesting background for the dresser set. Fine lines of ivory paint accent the curved routed edge of the mirror, on which the print is composed in a semicircle.

Takeo Asai, a pioneer of découpage in Japan, borrowed his designs *(opposite, below)* from a book on Japanese kimonos. In the backgrounds are other prints he also copied and handcolored so magnificently. Note the tiny gold-leaf flecks on the fan box, a traditional touch floated onto wet lacquer.

John Noble's artistry and imagination created these visual delights *(above)*. He photocopied illustrations for children's books and fairy tales. Carefully choosing his palette, he handcolored all the prints. Some of the "Faerie Boxes" are painted, others are colored more fancifully with metallic waxes.

At first glance, the ornate screen (opposite) seems quite
formal. Closer inspection reveals many whimsical details:
a butterfly resting on a bow, a bug crawling on the edge of
a border, a bird perched atop a frame, a branch growing
out of the picture onto the screen. "The more you look, the
more you see"—intriguing idea. Often, I cut a petal or
leaf and place it falling in space to suggest motion.

Color reproductions of Audubon's birds, framed in French
marble paper and hung with ribbons and bows, make a
quick and easy, attractive beginner's project (right). Vary
the shapes, but maintain balance.

Ann Huntington lightly antiqued her celadon fire screen
(below) for the drawing room at her Old Rectory in
Northamptonshire. The exquisite handpainted silk birds
and flowers hold their own, even facing the window view
of Annie's famous garden.

Robert Hendricks, connoisseur of fine imported champagne, collected the labels for years (and with much partying, I suspect). The composition on his screens is a tour de force, deserving careful study. He also made the tole tray for a wedding present, including the invitation to the reception. Gifts like these, one of a kind, will always be treasured.

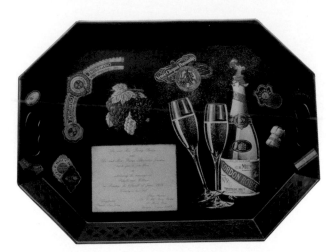

SOME OF MY
FAVORITE THINGS

"All things are literally better, lovelier and more beloved for the imperfections that reflect the human effort that went into their making." John Ruskin.

Most of the "favorites" that I have découpaged in the past two decades were exciting challenges for me. The extra effort that goes into trying something you've never tackled before is what makes it so special and so rewarding. Other "favorites" were created by friends and students, and I'm very pleased to include their beautiful and artistic work. This book wouldn't be complete without showing some of the advanced techniques, even though space doesn't permit detailed instructions.

The Christmas cornucopia decorations (page 121) were an inspiration from Victorian times. Over the years I've collected treasure boxes of ribbons, braid, ornaments, scrap, marble papers, satin fabric, and glazed and metallic papers. I had a wonderful time putting it all together, and it's easier than it looks. Using a compass on heavy stock paper, draw and cut out a 6-in. (15 cm.) quarter-circle with a 90-degree corner, plus a ½-in. (13 mm.) overlap. Spray-seal the chosen decorative papers, then cut them and/or fabrics to the shape of the quarter-circle cornucopia pattern. Glue the fabric and/or paper to both sides of the pattern with matte medium. Roll and form the cone; staple together at the top of the overlap and glue the length of the overlap with extra-thick white glue. Glue on ribbon or braid to cover the overlap and around the top, then add a loop for hanging. Decorate with scrap cutouts, jewels, etc., as much and as many as you like.

The red-and-gold box (page 121) découpaged with a holly and Christmas rose print I use for a centerpiece, filled with Christmas cookies.

Miniature furniture for doll houses is most definitely in the advanced category because of the scale and delicacy of the pieces. Working with such small proportions, I felt like I had giant-sized hands (I don't); even the tools I normally use are much too big. Reproductions from print catalogs are just the right scale. Some prints I cut out and some I used whole on a piece of furniture, painted to match the background color of the print. The *Chinoiserie* Room (pages 122–23) that I decorated and furnished with découpage now resides permanently at the Museum

of the City of New York, where there is an outstanding antique doll house and miniature collection.

"Paper sculpture," which requires several identical prints, is a popular technique for creating three-dimensional pictures (page 122). The details are cut, shaped, then attached with dabs of silicone adhesive in elevated layers, from background to the more detailed foreground. Beginners should choose a simple print to start with; later, several prints can be combined for a more intricate composition. These pictures require a deep shadow-box frame; however, they can also be mounted on a plaque and protected by several coats of spray finish.

The nursery furniture (page 123) was truly a labour of love for me—a grandmother's delight. The only thing in the room that was not découpaged was my granddaughter Amy. Brightly colored animals, flowers, and butterflies decorated the crib, tissue-box cover, wastebasket, and window shade—even a mobile hanging from the ceiling over the crib. Later, figures from her favorite books, *Peter Rabbit*, *Kate Greenaway*, *Mother Goose*, and *Snoopy*, were découpaged on a small chair, a toy chest, clothes rack, and more. All these family "heirlooms" Amy has outgrown, but she won't part with a single piece.

Patricia Nimocks is currently living in Santa Barbara, California, and teaching *réplique* cutting, or "drawing with scissors." Try this freehand cutting for yourself. Fold a square of origami paper in half with the color on the inside, then in half again. With a pencil, draw a simple design on one side (one quarter) of the folded paper. Thicken the pencil lines, as you will be cutting on both sides of them. Cuts should be mainly on the unfolded edges; only cut out small bits on the folded edges, since they are necessary to keep the paper together (if completely cut they would yield four separate replications). Do not open the paper until you are finished cutting. Patti recommends, "After you surprise yourself by cutting something you really like, incorporate the idea in another cutting and do it even better. The best paper cutters I have seen draw their own motifs easily and actually do the final drawing only with the scissors."

"Repoussé," like bas relief, creates a solid three-dimensional sculptured form, and requires two identical prints. Glue down the first print, then cut details from the second print, fill it with hand-moldable two-part epoxy putty, and glue it in place over the first print. Contour and sculpt the putty as it hardens, then varnish the surface. The advanced technique of sculpted prints combined with the flat découpage creates an attractive and unusual look (page 124).

Mr. Takeo Asai of Osaka was one of the first to introduce and teach découpage in Japan. His knowledge of textile design and color added to his talent for creating splendid oriental and European découpage. In addition to a demanding career, he has managed to spend many hours creating these unusual pieces (page 124). He colors black-and-white prints with fabric dyes, and découpages them onto custom-made furniture of his own design.

The "Faerie Box" series (page 125) evolved from the fanciful imagination of Mr. John Noble, the famous authority on dolls and doll houses. These might inspire your imagination. There are many wonderful book illustrations to use; you can color and cut out photocopies, or you can photocopy them in color, leaving the book intact.

Tall screens require great care in composing and represent the apogee of skilled scissors artistry. The Chinese invented this art form in the Chou Dynasty more than two thousand years ago; it was later adapted by the Japanese. As Janet Woodbury Adams shows in *Decorative Folding Screens*, "the opportunities for decoration offered by the folding screen have inspired artists and craftsmen for centuries." There is an "extraordinary diversity of materials, styles, and works by distinguished artists." Late-19th-century England had a flowering of made-at-home scrap screens; even doll houses had their own "scrap room" walls. Valentines, Christmas cards, and seed catalogs were often combined with engravings and photos for the découpage.

Screens can either be treated as individual panels or as a continuous picture plane. The angles of the upright panels can either counteract or accentuate the transition between the panels. Work the composition on the standing unfolded and angled screen; or make a paper pattern of the screen and hang it from the wall with strips of masking tape, and use the tape to hinge the panels. Patience is essential. The composition is a challenge, as it requires rhythm, balance, color, and movement. The reverse side of a screen can be treated differently—for example, with fabric panels, wallpaper, or faux finishes.

Inspired by the old print rooms, I adapted the idea for screens and included many more cuttings to embellish the whole prints (page 126). I've no idea how much time each screen took me; what really mattered was my pleasure in the creation and satisfaction with the results. A simpler version that a beginner can do is the Audubon screen (page 127). Ann Huntington of Rectory Designs, Sudborough, Northamptonshire, découpaged the fire screen (page 127) with cutouts from De Gournay's scenic, handpainted Chinese wallpaper.

A champagne connoisseur's delight is the pair of screens découpaged by Robert Hendricks for his dining room (page 128). Labels from all over the world were soaked off the (empty) bottles and découpaged with prints of grapes and leaves, corks, bottles, glasses, and ice cubes. The final varnish was spattered with solvent to imitate champagne bubbles. Robert also decorates tin trays (page 128) for wedding presents, using the invitation as part of the découpage—a thoughtful as well as a useful gift.

As I write this, I'm thinking about doing a powder room in print room style with French fashion prints bordered in velvet ribbons and bows. Then there's a baby grand piano that's waiting for my collection of prints of music and antique musical instruments. My "idea notebook" grows and grows. . . .

Reluctantly I leave you, with this last quote from Michelangelo's sonnet "Flesh and Spirit":

> *But, lady, feet must halt where sight may go:*
> *We see, but cannot climb to clasp a star!*

Keep on reaching for that star.

✂ SOURCES OF SUPPLY ✂

Many of the supplies and items of equipment needed for découpage can be readily acquired from a wide variety of retail outlets. Listed below is a selection of useful addresses, most of which will provide a catalog or brochure on request.

UNITED STATES AND CANADA

Paints, Finishes, Brushes, Hardware, etc.

Basic Crafts Company
1201 Broadway
New York, NY 10001

A. Constantine
2050 Eastchester Road
Bronx, NY 10461

Daniel Smith
4130 First Avenue
Seattle, WA 98134

A.I. Friedman
44 West 18th Street
New York, NY 10011

Garrett Wade
161 Avenue of the Americas
New York, NY 10001

Janovic Plaza
30–35 Thompson Avenue
Long Island City, NY 11101

New York Central Art Supply
62 Third Avenue
New York, NY 10003

Pearl Paint
308 Canal Street
New York, NY 10013

Sherwin Williams Canada, Inc.
170 Brunel Road
Mississauga, Ontario L4Z IT5

D.L. Stevenson & Son
1420 Warden Avenue
Scarborough, Ontario M1R 5A3

C.A.C. Talens, Inc.
2 Waterman Street
Saint Lambert, Quebec J4P 1R8

Prints, Scrap, Wallpaper, and Borders

Aiko's Art Materials Import
3347 North Clark Street
Chicago, IL 60657

Brandon Memorabilia
P.O. Box 20165
New York, NY 10011

Brunschwig & Fils
379 Third Avenue
New York, NY 10022

Dover Publications
31 East Second Street
Mineola, NY 11501

Ornamenta
c/o C. Hyland
979 Third Avenue
New York, NY 10022

Sonie Ames Designs
P.O. Box 1957
Paradise, CA 95967

The Twigs, Inc.
5700 Third Street
San Francisco, CA 94124

The Winslow Papers, Inc.
231 Lawrenceville Road
Lawrenceville, NJ 08648

Zuber & Cie
9979 Third Avenue
New York, NY 10022

Wood Products
Cabin Craft
P.O. Box 270
Nevada, IA 50201

Mill Store Products
P.O. Box 533
Dennisport, MA 02639

Gilding Supplies
Sepp Leaf Products, Inc.
381 Park Avenue South
New York, NY 10016

Découpage Specialist
Adventures in Crafts
P.O. Box 6058
Yorkville Station
New York, NY 10128

UNITED KINGDOM AND
IRELAND

Paints, Finishes, and Brushes
Auro Ireland Ltd.
Doon Lough
Firemilbourne
Sligo
Co. Leitrim

L. Cornelissen & Son Ltd.
105 Great Russell Street
London WC1B 3LA

Craig and Rose
172 Leith Walk
Edinburgh EH6 5EB

Daler-Rowney Ltd.
12 Percy Street
London W1A 2BP

Dryad Craft Centre
178 Kensington High Street
London W8 7RG

Farrow & Ball Ltd.
33 Uddens Trading Estate
Wimborne
Dorset BH21 7NL

Foxwell and James
57 Farringdon Road
London EC1M 3JH

Green and Stone
259 King's Road
London SW3 5EL

Greyfriars Art Shop
Greyfriars Place
Edinburgh EH1 2QQ

J.H. Ratcliffe
135a Linaker Street
Southport PR8 RDF

S. Stevenson
68 Clerkenwell Road
London EC1M 5QA

Paper and Scrap
De Gournay
41 Brompton Square
London SW3 2AF

Dover Bookshop
18 Earlham Street
London WC2H 9LN

Falkiner Fine Papers Ltd.
76 Southampton Row
London WC1B 4AR

Hawkin & Co.
St. Margaret
Harleston
Norfolk IP20 0PJ

Mamelok Press Ltd.
Northernway
Bury St. Edmunds
Suffolk IP32 6NJ

Paperchase Products Ltd.
213 Tottenham Court Road
London W1P 9AF

"Print Room"
Prints and Borders
Irish Georgian Society
Leixlip Castle
Leixlip
Co. Kildare

National Trust
36 Queen Anne's Gate
London SW1H 9AS

Nicola Wingate-Saul Print Rooms
43 Moreton Street
London SW1V 2NY

Ornamenta Ltd.
P.O. Box 748
London SW7 2TG

Gilding Supplies
Stuart R. Stevenson
68 Clerkenwell Road
London EC1M 5QA

Découpage Specialists
Belinda Ballantine
The Abbey Brewery
Malmesbury
Wiltshire SN16 9AS

Rectory Designs
The Old Rectory
Sudborough, nr. Kettering
Northamptonshire NN14 3BX

AUSTRALIA AND
NEW ZEALAND

Aidax Industries
64–68 Violet Street
Revesby
Sydney, NSW 2212

Bristol Decorator Centre
76 Oatley Court
Belconnen, ACT 2617

The Complete Look
20 Karalta Road
Erina, NSW 2250

Country Colours
10 Broadway
New Market, NZ

Golding Handcraft Centre
161 Cuba Street
P.O. Box 9022
Wellington, NZ

Oxford Art Supplies Pty Ltd.
221–223 Oxford Street
Darlinhurst, NSW 2010

⊰ BIBLIOGRAPHY ⊰

Adams, Janet Woodbury, *Decorative Folding Screens*, London and New York 1982

Albers, Josef, *Interaction of Color*, New Haven and London 1963

Ballantine, Belinda, *The Decoupage Kit*, London 1993

Bourne, Jonathan *et al.*, *Lacquer: An International History and Collector's Guide*, Marlborough 1984

Butterfield, Oliver, "Bewitching Witchballs" in *Yankee Magazine*, July 1978

Cennini, Cennino, *The Craftsman's Handbook*, New Haven 1932, London 1933

"Le Charme Révolu des Bois de Spa" in *Connaissance des Arts*, 1979

Chippendale, Thomas, *The Gentleman and Cabinet-Maker's Director*, London 1754, (new edn.) Ware, Herts. 1990

D'Amico, V., and A. Buchman, *Assemblage*, New York and London 1972

Dampierre, Florence de, *The Best of Painted Furniture*, New York and London 1987

Davis, Dee, and Dee Frenkel, *Step-by-Step Decoupage*, New York 1976

Del Puglia, Raffaella, and Carlo Steiner, eds., *Mobili e ambienti italiani dal Gotico al Floreale*, 2 vols., Milan 1963

Duer, Caroline, "Découpage" in *House and Garden*, Dec. 1949

Dutton, Ralph, *The English Interior 1500–1900*, London 1948

Edwards, Betty, *Drawing on the Artist Within*, New York 1986

Edwards, Betty, *Drawing on the Right Side of the Brain*, New York 1979

Elderfield, John, *Exhibiting Henri Matisse*, New York 1992

Elderfield, John, *Henri Matisse: A Retrospective*, New York and London 1992

Field, June, *Collecting Georgian and Victorian Crafts*, London and New York 1973

Godey's Lady's Book, Philadelphia Jan. and June 1855

Gordon-Clark, Jane, *Paper Magic*, New York and London 1991

Grotz, George, *The Furniture Doctor*, Garden City, NY 1962

Guinness, Desmond, "The Reviving Pleasure of the Print Room" in *House and Garden*, Sept. 1978

Habsburg, Géza von, *Gold Boxes, from the Collection of Rosalinde and Arthur Gilbert*, London 1983

Harrower, Dorothy, *Decoupage: A Limitless World in Decoration*, New York, 1958

Hayden, Ruth, *Mrs. Delany: Her Life and Her Flowers*, London 1980

Honour, Hugh, *Chinoiserie*, New York and London 1961

Housley, S.J., "Great Men's Shadows" in *The Strand Magazine*, Vol. XII, 1896

Huth, Hans, *Lacquer of the West*, Chicago 1971

Jackson, Valerie, *Découpage*, London 1974

Klee, Paul, *The Thinking Eye*, New York 1961

Kramer, Hilton, *Age of the Avant-Garde*, New York 1973

Lang, Donna, and Lucretia Robertson, *Decorating with Paper*, New York 1993

Levy, Saul, *Lacche veneziane settecentesche*, 2 vols., Milan 1967

Linsley, Leslie, *Découpage: A New Look at an Old Craft*, Garden City, NY 1972, London 1975

Lorenzetti, Giulio, "Lacche veneziane del settecento," exh. cat., Ca' Rezzonico, Venice 1938

Lorrimar, Betty, and Margaret Hickson, *Ideas for Decoupage and Decoration*, New York 1975

"The Lost Art of Filigree Paperwork," exh. cat., Florian Papp Antiques, New York 1989

Lynn, Catherine, *Wallpaper in America*, New York 1980

McCloud, Kevin, *Decorative Style*, New York 1990

Manning, Hiram, *Manning on Decoupage*, Great Neck, NY 1969

Matisse, Henri, *Jazz*, Paris 1947

Mazzariol, Giuseppe, *Mobili italiani del Seicento e del Settecento*, Milan 1963

Messer, Thomas, "Jiří Kolář," exh. cat., Guggenheim Museum, New York 1975

Meyer, Franz, *A Handbook of Ornament*, New York 1888, London 1893, (new edn.) London 1974

Mitchell, Marie, *The Art of Decoupage*, Detroit 1966

Mitchell, Marie, *Advanced Decoupage*, Detroit 1971

Morazzoni, Giuseppe, *Mobili veneziani laccati*, 2 vols., Milan 1954–57

More, Hilary, *Easy to Make Decoupage*, London 1993

Nimocks, Patricia E., *Decoupage*, New York 1968

O'Neil, Isabel, *Art of the Painted Finish for Furniture and Decoration: A House and Garden Book*, New York 1971

"Penwork: The Triumph of Line," exh. cat., Hyde Park Antiques, New York 1989

Pignatti, Terisio, *The Age of Rococo*, Feltham, Middx. 1969

Priolo, Joan Burgher, *Decoupage: Simple and Sophisticated*, New York, London, and Sydney 1974

Raymond, Audrey, *Découpage: A Practical Guide*, East Roseville, NSW and London 1993

Reader's Digest Association, *Crafts and Hobbies*, Pleasantville, NY 1979

Ritchie, Carson, *Art in Paper*, London 1976

Roche, Serge, "Le Décor Scriban" in *Plaisir de France*, Christmas 1960

Roderick, P., *Gloria Vanderbilt Designs for Your Home,* New York 1975

Sayer, Robert, *The Ladies Amusement; or, Whole Art of Japanning Made Easy*, London [c. 1760], (new edn.) Newport, Mon. 1959

Singleton, Nerida, *Découpage: An Illustrated Guide*, Birchgrove, NSW 1991

Sommer, Elyse, *Decoupage Old and New*, New York 1971

Sommer, Elyse, *Designing with Cutouts: The Art of Découpage*, New York 1973

Stalker, John, and George Parker, *A Treatise of Japanning and Varnishing*, 1688, (new edn.) London 1960

Thomas, Denise, and Mary Fox, *Practical Decoupage*, London 1993

Wing, Frances S., *The Complete Book of Decoupage*, New York 1965